Different strokes:
watercolor

Different strokes:
watercolor

Naomi Tydeman

Walter Foster

A QUARTO BOOK

Copyright © 2008 Quarto Inc.

First edition for North America
published in 2008 by

Walter Foster Publishing, Inc.
23062 La Cadena Drive,
Laguna Hills, CA 92653
www.walterfoster.com

Walter Foster is a registered trademark.

ISBN-13: 978-1-60058-053-6
ISBN-10: 1-60058-053-X
UPC: 0-50283-43202-9

Conceived, designed and produced by
Quarto Inc
The Old Brewery
6 Blundell Street
London
N7 9BH

QUAR.CART

Project Editor **Rachel Mills**
Art Editor **Julie Joubinaux**
Editorial Assistant **Robert Davies**
Designer **Michelle Cannatella**
Photographer **Martin Norris**
Indexer **Dorothy Frame**
Picture Researcher **Claudia Tate**
Art Director **Caroline Guest**
Creative Director **Moira Clinch**
Publisher **Paul Carslake**

Manufactured by PICA Digital, Singapore

Printed by 1010 Printing International Limited, China

9 8 7 6 5 4 3 2 1

Contents

Introduction

It is fascinating to observe how two artists given the same starting point approach the subject differently—and this book shows you just that. By comparing the way two artists work you can understand more about the character and possibilities of this fantastic medium, watercolor. Technique, color preferences, methods, and materials vary from artist to artist, and this book celebrates these differences and shows you that there is no right or wrong way to approach a painting. Some artists work in a detailed way, whereas others prefer a looser and more impressionistic look. Some start by painting the details, and others begin with an overall wash. This book is laid out so that you can simultaneously compare the two artists' work stage by stage, seeing how different techniques, compositional decisions, and approaches can achieve different results within the same framework. If you are just starting to paint in watercolor, choose a painting and an approach you like and work along

About this book

The first section of this book gives advice for getting started and explores the different tools and materials that are available to watercolor artists. This section also demonstrates some of the approaches and techniques of watercolor painting, with sequences that describe ways to achieve different effects and exercises for gaining confidence and control.

The second section includes 12 demonstrations and is the core of the book. The sequences of steps are clearly laid out with each so you easily can compare, contrast, and digest the different methodology and approaches that are involved. As shown below, the artists share the same reference image, but their starting point often varies and the outcomes can be vastly different. Sometimes the artists work in very different ways but might use a similar technique to describe, for example, the shape or depth of a shadow. Refer to the "mirrored" stage sequences to understand the working methods of each artist.

Clear step-by-step sequences that show the principle watercolor techniques.

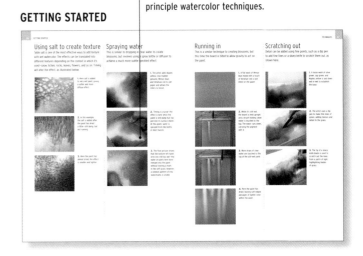

GETTING STARTED

COMPARING TECHNIQUES

Artist 1 (top half of the page).

Artist 2 (lower half of the page).

The photograph shows you the point of reference for the artists.

The tools, materials, and colors used by each artist are listed.

Any sketches or preparatory work that the artist has used suggest ways you can get started.

Large, clear photographs show how each artist works. All the stages are shown at the same size for easy comparison.

with the sequences. If you are more experienced with watercolor, mix and match techniques or color palettes from the two demonstrations, or from the whole book. You also can apply individual artists' ideas to your own work. Being faced with a blank sheet of paper can induce both excitement and fear in beginning and experienced artists alike. This book demonstrates how initial decisions and subsequent choices will radically affect the outcome. Learn what works for you and what your preferences are, and be confident in them.

Working from the photographs in this book

Photographs make great resource material, and artists use them for different reasons—from a simple, initial impulse for remembering the effect of light on a landscape or some technical detail to freezing movement and creating a photorealistic representation. Use the photos in this book to inspire your own interpretation, and then compare your work with the featured artists'. You also can mix techniques from different demonstrations to produce your own unique paintings.

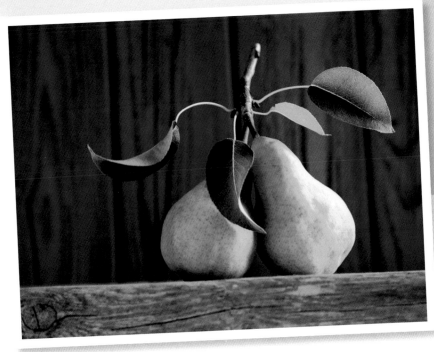

Specially selected photographs show a broad range of subjects. These images are the point of reference for the artists, and you can see how each interpreted the subject in his or her own way.

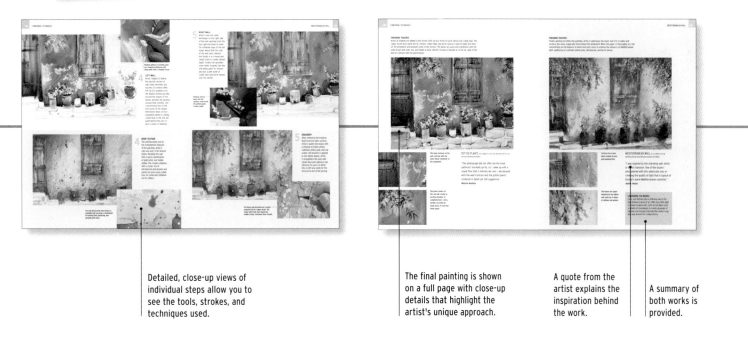

Detailed, close-up views of individual steps allow you to see the tools, strokes, and techniques used.

The final painting is shown on a full page with close-up details that highlight the artist's unique approach.

A quote from the artist explains the inspiration behind the work.

A summary of both works is provided.

Tools and materials

The amount and range of watercolor materials available can be overwhelming. As you purchase supplies, remember that it's wise to start with a basic selection of good-quality tools rather than larger quantities of cheaper materials.

WATERCOLOR CHOICES

Watercolor paints are sold in three basic forms: pans, cakes, and tubes. Pans or half-pans are semi-moist wells of paint, and cakes are dry blocks of pigment. To create washes of color with pans and cakes, gently scrub the surface of the paint with a wet brush to release the pigment. Tubes, which contain already-moist paint, are a more popular form of watercolor paint because you can readily squeeze the desired amount of paint onto a palette, making it simple to create large washes. When you purchase tubes of watercolor paint, they may seem small—especially compared to acrylic and oil tubes—but remember that just a little watercolor paint goes a long way.

PAINTBOXES

Pans and cakes are typically stored in watercolor box sets called "paintboxes" that double as mixing palettes and can be snapped shut—features that make them convenient for painting on location. Often a paintbox will come with a selection of pans; however, these can be removed and replaced to suit your desired palette, as pan colors can be purchased separately.

BUY THE BEST

When purchasing watercolors, look for the label "artists' watercolor," and don't be tempted to buy the less expensive paints. Known as students' colors, these contain less pure pigment and may lead to disappointment. This advice also applies to pans of paint.

TYPES OF PAPER

1 Handmade paper

2 Extra rough, mold-made artist's board

3 Cold-pressed (Not) paper

4 Rough, machine-made paper

5 Hot-pressed (smooth), machine-made paper

6 Rough paper

WATERCOLOR PAPERS

If you visit a specialist supplier, you will find a bewildering variety of handmade watercolor papers, but most artists use machine-made papers, which are available from all art stores. These are the best ones to start with, and you can experiment with more exotic papers later if you wish. Machine-made papers come in different surfaces, of which there are three main categories: smooth (otherwise known as "hot-pressed" or "HP" for short); medium (sometimes called "cold-pressed," "CP," or "Not"—meaning not hot-pressed); and rough (also cold-pressed, but with a much more pronounced texture). Although some artists choose smooth or rough paper for special effects, the all-around favorite is cold-pressed, which has enough texture to hold the paint but not enough to interfere with color and detail. If you want to experiment with textures and effects on watercolor paper, use a good-quality, heavy paper or watercolor board, which can stand up to heavy washes and a fair amount of brush action. A heavyweight paper or board will not need stretching and should soak up a lot of water without disintegrating.

BRUSHES

Most people agree that the best brushes to use for watercolor work are sables. However, sables are expensive, and there are many excellent synthetic brushes as well as sable and synthetic mixtures that are quite adequate for most purposes. Regardless of the brush's makeup, the bristles should have good spring, or resilience of the bristles. You can test the spring by wetting your brush to a point and dragging it lightly over your thumbnail; bristles with good spring will return to their original position. You also need your brushes to hold a good quantity of water—you can test this easily by loading the brush with water and then squeezing it out.

BRUSH SIZES

Remember that the larger the brush head, the more paint it will hold and the bigger the stroke it will make, so be sure to have a selection of brush sizes available. However, don't go overboard and buy a whole range—one large, one medium, and one small are all that you'll need. Keep in mind that some artists use only one brush.

Chinese brushes
If you can only afford a few brushes, Chinese brushes are a wise choice, as they can create a wide variety of strokes and are much less expensive than sable brushes. They are becoming very popular with artists, especially those who like to exploit the marks of the brush in their work.

ARTIST'S TIP

As water is the primary medium for watercolor work, you do not strictly need anything else, but there is one medium that is useful on occasion. This is gum arabic, which is used in the manufacture of watercolor. It can be mixed with paints on the palette to give the paint more body and a slight gloss without affecting its transparency, allowing it to hold the marks of the brush and become more controllable. It also is an aid to the lifting-out technique (see page 22). Never use gum arabic straight from the bottle, as it may cause the paint to crack. It should be mixed with water to a proportion of about one part gum arabic to three parts water.

Another medium for watercolor work is oxgall. This is a water-tension breaker that has the opposite effect as gum arabic, helping the paint to flow more smoothly.

OTHER EQUIPMENT

A small, natural sponge forms part of most watercolorists' kits. This can be used for washing off paint when a mistake has been made and for softening edges, as well as for laying washes and lifting out. Another standard item of equipment for many artists is liquid frisket (masking fluid), which helps reserve highlights. Finally, you will need pencils for sketching, boards for supporting the paper, and, last but not least, receptacles for holding water. Jam jars can be used for indoor work, but these are uncomfortably heavy for outdoor painting. A variety of light, plastic water containers is available, including a type with a non-spill lid.

Masking fluid
This is essential for reserving small highlights that can't easily be avoided while painting. Always use an old brush to apply the fluid, and rinse it immediately, as it is almost impossible to remove from the hairs once dry.

Paper towels
This material is ideal for general cleanup purposes. It also is useful for various lifting-out methods and for blotting off excess paint at the bottom of a wash.

Gummed tape
Also called "artist's tape," this is used for stretching paper. Never try to use masking tape for this.

Masking tape
If you work on loose sheets of paper rather than sketchpads, tape is essential for securing it to the drawing board. Thumbtacks can be used if the board is relatively soft wood, but they won't usually penetrate harder surfaces such as masonite or plywood.

Sponges
Small, natural sponges are sold in most art stores. They are most often used for lifting out and removing paint, but you can also apply paint with them to build up interesting textures.

Cotton swabs
These are useful for lifting out small areas of dried color, either to make minor corrections or to create highlights.

Pencil and eraser
You will need one or more pencils to make the preliminary drawing and a plastic eraser to correct any mistakes. Many different grades of pencil are available, but B is a good all-around choice, and is soft enough not to indent the paper.

Types of sketches

Sketching is as important as the foundations of a house; it will give your painting a good grounding, whether you plan it out on your watercolor paper or work in a sketchbook and transfer it. Whatever method works for you, the important thing is that some planning, structure, and thought has already happened before the painting starts. Most of the artists featured in this book work out their sketches in a different manner and create them for different reasons.

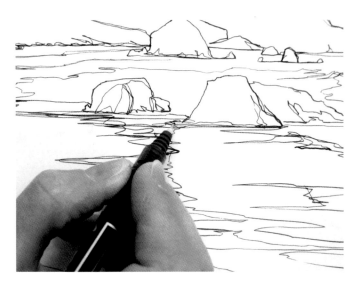

CONTOUR DRAWING
In this method of drawing, the pen follows the outlines and major differences in value (darks and lights). The artist rarely lifts the pen from the paper, creating a continuous line of rhythm and movement.

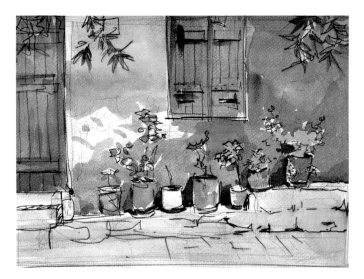

COLOR SKETCH
This quick color sketch shows that drawing is not always about line. Here, the artist establishes the color and tonal pattern before confidently embarking on the painting.

COMPOSITIONAL SKETCH
A simple outline is drawn directly onto the watercolor paper, acting as a map, plotting the information.

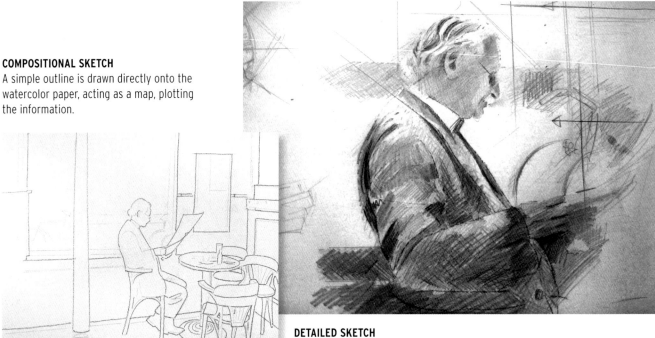

DETAILED SKETCH
A closer study of something as important as a face allows the artist to become more familiar with its characteristics.

GESTURED SKETCH
A precise yet fluid line drawing captures the flowing forms of a flower.

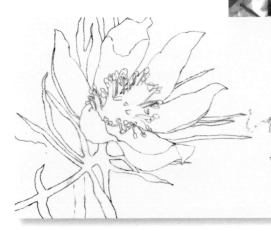

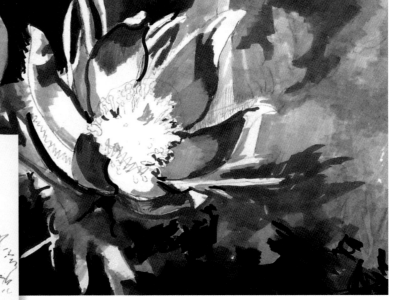

TONAL SKETCH
This tonal sketch was done using gray-scale markers, illustrating the intense contrasts between the darks and lights and helping the artist to be more confident in the tones when applying color.

TWO-TONE SKETCHING
This stylized method of shading simplifies the picture into two tones only, which helps separate dark colors from light colors in the painting.

HIGHLY DETAILED DRAWING
An intensely detailed drawing on watercolor paper leads to an extraordinarily controlled application of paint.

OUTLINE SKETCH
Fine lines indicate changes of value, and the edges of objects, setting the scene for a pattern of color and form.

THUMBNAIL SKETCH
This traditional pencil sketch softly works out the forms of the main elements and their relationship to one another.

Choosing a drawing medium

The medium you choose for outdoor sketching depends on how much time you have, and whether you intend just to make visual notes or produce a sketch that stands as a work in its own right. Pencil, charcoal, and watercolor pencils all are ideal for quick sketches, whereas pen and ink are better for a well-realized drawing.

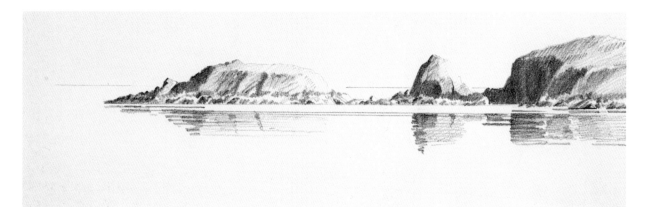

PENCIL SKETCH
Hatching with a pencil and building up tone and texture with subsequent layers or pressure is probably the most convenient of all sketching methods. This drawing was created with a 6B pencil on cartridge paper.

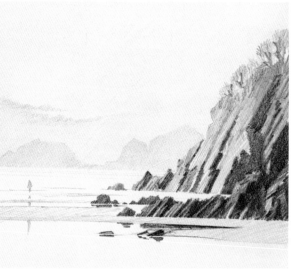

WATERCOLOR PENCILS
Watercolor pencils have all the convenience of pencils but are water-soluble. Carrying a brush and a small jar for water on your sketching trips will allow you to create the subtle shades and tones of a watercolor without the weight and mess of a paintbox. Watercolor pencils come in numerous colors and can be worked into damp paper for extra depth and density. This example was worked quite heavily using a single color on watercolor paper.

DIFFERENT LEADS
Pencils are graded on a scale from soft (labeled "B") to hard (labeled "H"). The higher the number that accompanies the letter, the softer or harder the graphite. Softer leads create dark tones that are excellent for shadow and depth. Harder leads create tones that are lighter and finer, making them great for detail work. You can use a combination of leads to emphasize the differences in value and texture as shown in the sketch above, which was created with 2H, 2B, and 6B pencils.

FINE-LINE PEN
Pre-loaded ink pens are convenient if you want to use line alone and are not concerned with tone. In this quick drawing, the subject has been reduced to a simple pattern of shapes.

PEN AND INK

Fine-line pens have replaced the fountain pens and ink bottles of earlier times but involve the same principles. It is an unforgiving medium, but its boldness and strength can be striking. Use hatching and crosshatching to build up depth in much the same way as you would with a pencil.

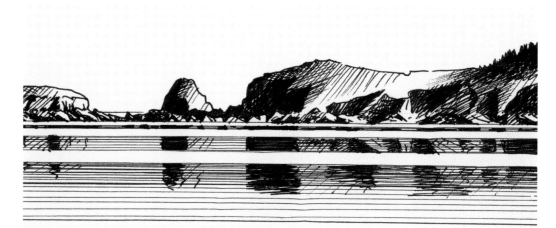

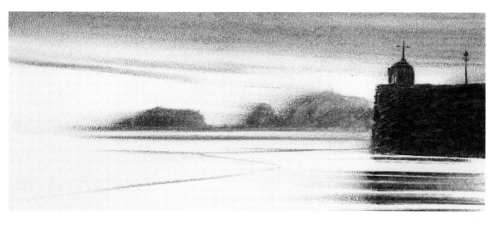

CHARCOAL

Charcoal is quick, expressive, and good for capturing a mood. Its great advantage—or fault—is that it smudges easily and is therefore very messy, but for ease of expression, it is hard to beat. This sketch took four minutes and was done using willow charcoal on cartridge paper.

SHADING WITH DOTS

Creating shadows and texture with small dots using a pen gives an effect reminiscent of photographs reproduced in a newspaper. It is a relatively slow process, but the results are soft and subtle.

INK WASHES

For this sketch, various diluted washes of India ink were brushed onto watercolor paper. Being able to achieve every tone—from the lightest, thinnest wash to the rich intensity of pure ink—makes ink washes an excellent way to record tonal values.

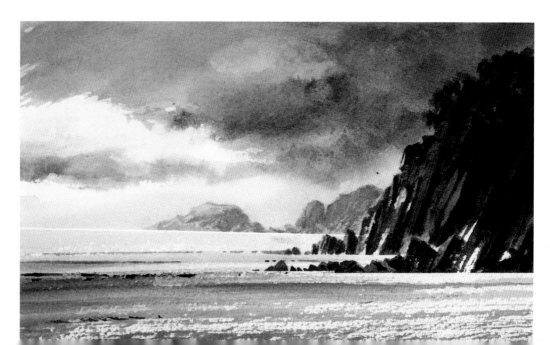

Color

Color is probably the aspect of painting most open to personal preference. From the colors we paint our rooms and the colors we wear to the time of year we prefer, color affects everyone differently.

PALETTES

Your choice of colors (your palette) may be governed by your subject matter, or you might have favorite colors that you know work well. It is useful to be able to predict the colors that you can make either by premixing on the palette or directly on the paper. It is a good idea to introduce a new color to your palette every now and then just to experiment. Study the different palettes used by the artists in the book. Most of the artists use between six and ten different pigments, which shows that you don't need many colors to achieve a wide range of color in your painting mixes. Some artists use a limited palette (see page 15). This can be an interesting way to work as it encourages you to understand how primary and secondary colors perform.

PRIMARY AND SECONDARY COLORS

Red, yellow, and blue are the primary colors—they are the building blocks of your palette. However, there are many different types (or hues) of each; for example, vermillion, quinacridone red, cadmium red, and scarlet are hues of red. Shown below are variations of each color—one warmer and one cooler. From these primaries you can mix secondary colors, which include green, orange, and violet.

Mixing warm primary colors creates vibrant oranges, mossy greens, and a warm mauve.

Mixing cool primary colors makes the purest greens and violets, but subtler oranges.

WARM AND COOL

Each of the primaries shown here consists of two versions, a warm and a cool. Lemon yellow is cool because it has blue in it; cadmium yellow is warm because it has red in it. Alizarin crimson is cooler than cadmium red because it's tinted with blue, and ultramarine is warmer than Winsor blue because it contains a little red.

COOL

Lemon yellow Alizarin crimson Winsor blue

WARM

Cadmium yellow Cadmium red Ultramarine blue

COLOR WHEEL

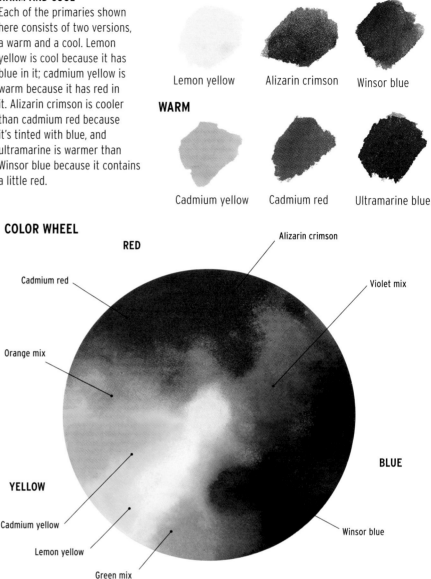

RED

Cadmium red

Alizarin crimson

Orange mix

Violet mix

YELLOW

BLUE

Cadmium yellow

Lemon yellow

Winsor blue

Green mix

COMPLEMENTARY COLORS ON THE WHEEL

The color wheel illustrates how the three primary colors interact and blend with one another. Complementary colors are those opposite each other on the wheel—red and green, yellow and purple, and blue and orange. Side by side, complementary colors produce vibrant contrasts, but also can be mixed to produce natural colors.

NEUTRAL COLORS

Most colors you'll find in nature are more subtle and muted than the vibrant, pure color that comes straight from the tube. This is why it is so important to learn to mix your own natural-looking colors. When mixed, two complementary colors "gray" each other, producing a neutral color. You can achieve the same effect by producing a mix of all three primaries—vary the quantity of each to produce a range of dynamic neutral colors.

COMPARING PALETTES

Compare the palette each artist uses to paint the pears (see page 78). The individuality of choice can be seen here: one artist uses twelve pigments whereas the other uses a limited palette (see below) of just four. Both are equally effective. Follow the sequence and see how each artist mixes or layers colors to achieve the desired results.

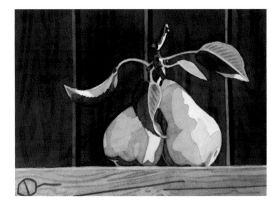
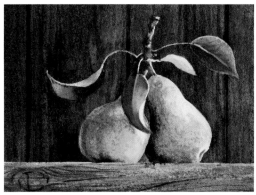

Palette
Ultramarine blue	Lamp black
Mauve	Winsor green
Sepia	Van Dyke brown
Burnt sienna	Sap green
Winsor blue	Aureolin
	Hunter's green

Palette
Winsor blue
Venetian red
Winsor lemon
Manganese blue

LIMITED PALETTE

It is not only simple still life paintings that can be painted with a limited palette. This complex painting of the Rockies (see page 54) uses combinations of only four colors. The limited palette is a wonderful way for an artist to consider the tonal values of a painting. Without the distractions of too many colors, attention is focused on the intensity of lights and darks.

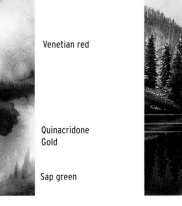

Winsor blue

Venetian red

Quinacridone Gold

Sap green

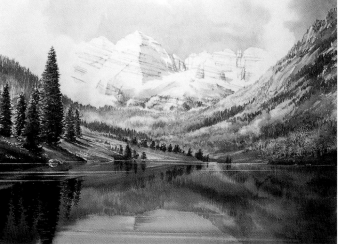

WARM AND COOL MIXES

These two paintings show how the atmosphere of a painting can be affected by the use of color. Both scenes are painted with the same two colors—Winsor blue and Venetian red—yet one is cool and the other warm. This is achieved by altering the ratio of blue to red. The smallest touch of cadmium yellow in the painting of the river makes it warm.

Winsor blue

Venetian red

Mix of blue and red

Gray mix with more red

Gray mix with more blue

Composition

Composition is the arrangement of elements within a space, and good composition is essential to any painting. A pleasing composition will appear harmonious and balanced, with all the elements working together to create an eye-catching scene.

Here are several suggestions to help you achieve balance in your paintings.

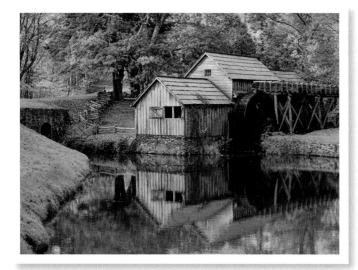

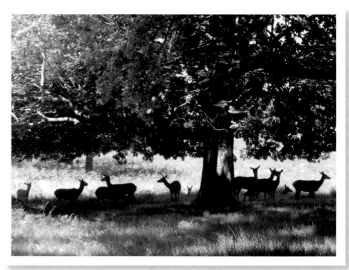

DETERMINING THE FOCUS

Every composition needs a focal point, or center of interest. A focal point can be something obvious like a person or an object, or it can be more subtle, like gleaming highlights on the side of a hill or a pattern of shadows on a street. In this photograph, the colorful reflections are so compelling that they become the focus of the painting.

THE RULE OF THIRDS

Once you've established a focal point, it's important to place it correctly within the scene. A good way to do this is to follow the rule of thirds. Divide the painting surface into thirds horizontally and vertically; then place your focal point (in this case, the tree) at or near one of the points where the lines intersect. This keeps your center of interest away from the extremes— corners, dead center, or at the very top or bottom of the composition.

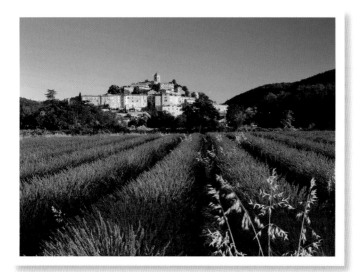

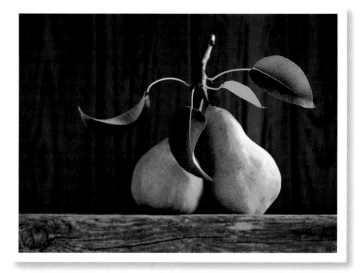

LEADING THE EYE

A good composition should contain visual passages that lead the viewer's eye into and around the entire painting. A great way to create a visual passage in a painting is to incorporate diagonal and curved lines that lead the eye to the center of interest. In this photograph, the diagonal rows of lavender lead the eye directly to the distant sunlit village.

CREATING CONTRAST

The eye is drawn toward areas of strong contrasts in value as well as to pure color, so your composition should include a variety of light, medium, and dark values to help direct the viewer's eye. In this photo, the brightly lit side of the right-hand pear contrasts with the dark background, attracting immediate attention.

USING A VIEWFINDER

Cut two L shapes from cardboard and paperclip them together to form a square or a rectangle. Look at your scene through the viewfinder—bring it closer and hold it out farther, move it around the scene, and make the opening wider and narrower until you find a pleasing composition.

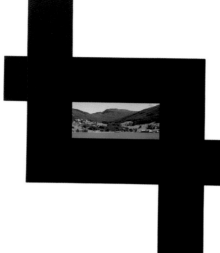

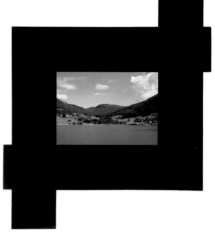

CROPPING

For the purposes of this book, the contributing artists were asked not to crop the images. However, cropping a photo reference often can enhance a composition, allowing you to zoom in on certain elements. Below is an example of how cropping this photo of a man reading in a café could create another pleasing composition.

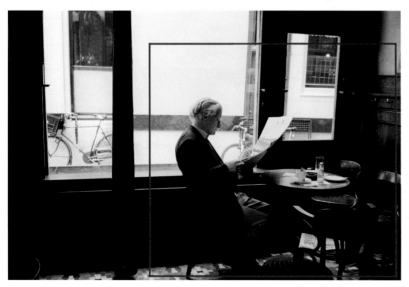

CAFÉ INTERIOR

Eliminating the left side and most of the background of the original photograph makes the scene tighter, closer, and more intimate. This cropping was done on a computer, but you also can use a viewfinder to experiment with cropping.

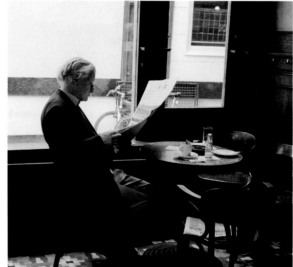

Techniques

Watercolor is an amazing medium—once mixed with water, it takes on all the properties of that element. Water responds to the laws of gravity and evaporation; exploiting those laws is the basis for many different watercolor techniques.

Stretching paper

Watercolor paper lighter than 140 lb (300 gsm) should be stretched so it doesn't buckle when paint is applied. When stretching paper, allow at least two hours for the paper to dry.

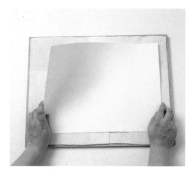

1. Place the paper face down on top of dry paper towels and a sturdy surface, such as a board.

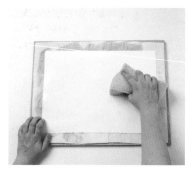

2. Dip a sponge in water and lightly dab it on the back of the paper. The paper towels will absorb any residual water that seeps through to the front of the paper.

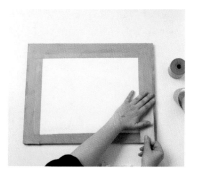

3. Turn the paper over and remove the towels. Secure the paper to the board with artist's tape. Stand the board upright until the paper is completely dry.

Flat wash

The flat wash is the most basic of all watercolor techniques and forms the foundation of many paintings. For a uniform layer of coverage, be sure to mix enough paint upfront to coat the entire area.

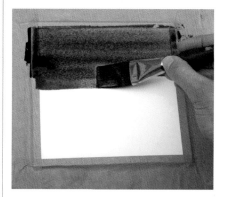

1. Starting with a wide, flat brush, load enough diluted color (in this case, Winsor blue and Venetian red) to make one stroke across the top of the paper. Tilting the board slightly toward you allows the paint to flow downward.

2. Continue down the paper quickly, not allowing the paint to dry between strokes. Work back over uneven lines if necessary to even out any discrepancies in the wash.

3. Continue down to the base of the paper, tilting the board to encourage even flow of the pigment before it settles.

4. Here the paint has dried to a flat, even finish. Some pigments will granulate and produce a grainy effect. Get to know the paints in your palette before applying them to your painting.

Graduated wash

Graduated washes are again a basic technique, but this time the artist uses water to dilute the pigment between strokes for a gradual thinning and lightening of color. Graduated washes form the basis for many skies.

1. Using the same Winsor blue and Venetian red mix as for the flat wash, lay down a couple of brushstrokes, left to right, across the top of the paper.

2. Continuing down the paper add less pigment and more water until the final brushstroke is just water.

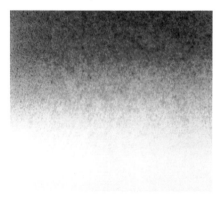

3. Lay the board flat for the wash to dry. If you tilt it, the stronger pigment will run down into the lighter areas.

Variegated wash

The variegated wash is simply blending two or more colors together in a manner that produces a seamless transition between them. The wider the flat brush you use, the fewer the number of strokes, and the better the gradation.

1. Brush blue paint from left to right across the top of the paper, moving down almost to the center.

2. Rinse the brush before washing pink across the base of the paper. Stroke with the brush where the two colors meet to help blend them.

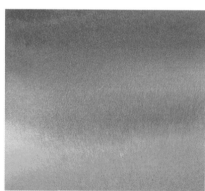

3. While the paint is still wet, gently tilt the board upward, downward, and sideways to allow the paint to flow and blend.

Wet-in-wet

Wet-in-wet is one of the most wonderful techniques to use with watercolor, as it allows colors to flow into each other with no defined edges. Gravity and time contribute to the final effect of the work.

Wet-on-dry

Painting wet-on-dry enables you to overlap washes, and as long as there is as little disturbance as possible to the pigment underneath, you can achieve translucent layers of clear color.

1. The artist begins by dropping rose madder genuine onto wet paper followed by a dark purple.

1. Once the sky has dried, the artist applies a pale wash of Naples yellow and gray for the most distant row of hills. This wash is carried to the bottom of the paper.

2. As more colors are added, the colors start to flow and blend into one another.

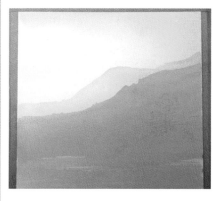

2. Adding a little more color to the wash and making sure the previous layer of paint is dry, another layer is added and carried to the base of the painting.

3. To create more flow and intensity of color, the artist pours paint straight from the palette. At this stage, it is very wet.

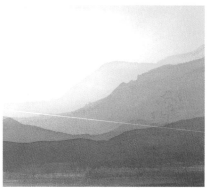

3. By adding a little more pigment to each subsequent layer, the range of hills is built up. The strokes toward the base of the picture are drybrushed (see page 23) to bring texture and sparkle to the lake.

4. The painting has been set to one side where the color has continued to flow until it has dried. Controlling the wet-in-wet technique is virtually impossible, but experience will bring good judgment.

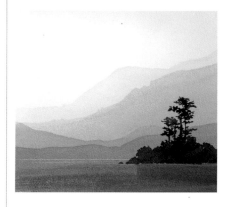

4. When the paint is dry, the tree and the island are added using a small round brush and a strong gray mix. Finally, the front of the lake and the reflection of the island are painted with a mid-gray wash.

Glazing

Glazing is another form of layering wet-on-dry. Here it is illustrated using color to show how the pigment underneath can affect the layers laid on top. Allow each layer to dry completely before applying the next.

Masking out

Masking fluid is used to reserve whites or highlights, forming a waterproof seal that protects the paper underneath. It enables washes to be painted over without having to carefully leave tiny areas white.

1. A thin wash of cadmium yellow is laid down and allowed to dry.

2. The second layer is rose madder genuine, another transparent pigment. The layering creates a glowing orange.

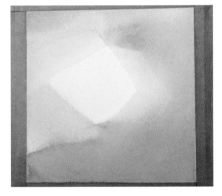

3. Winsor blue forms the third glaze, creating a tertiary color over the orange and a turquoise where it interacts directly with the central yellow area.

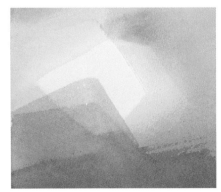

4. The final wash is a thin layer of dioxazine violet which creates a new range of colors.

1. Here the artist has masked out all the white areas of a backlit magnolia. Use old brushes or a color shaper to apply masking fluid, as it cannot be washed out once allowed to dry.

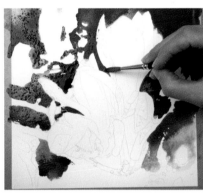

2. Masking fluid allows a speed and fluidity in the application of paint, which in the final work is interpreted as confidence.

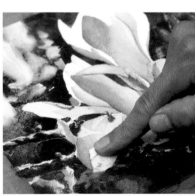

3. Once the shadows have been painted and allowed to dry, the masking fluid is rubbed or peeled off, revealing the white paper beneath. Use a rubber glove for large areas to prevent blisters.

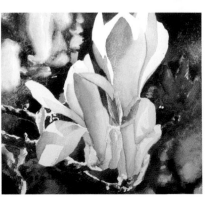

4. Sometimes the paper appears too white when the fluid is removed, so the area must be lightly colored, but in this case the pure whites are ideal for the subject, and the crisp edges describe the forms of the petals perfectly.

Lifting out (wet)

Lifting out paint while it is still wet is another technique used often by watercolor artists. Any absorbent material can be used to soak up the paint, such as paper towels or cotton swabs.

Lifting out (dry)

Paint can still be lifted out once it has dried. A stiff-bristle brush is needed, along with clean water and a tissue for soaking up the dislodged pigment. Some papers are too soft for this, so check first.

1. A wash of soft gray and Naples yellow is painted to form the base of a sky.

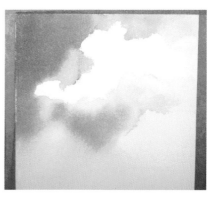

1. Here the paint is worked around areas of clean dry paper to form loose cloud shapes.

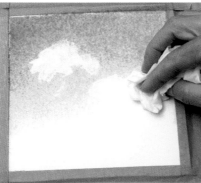

2. While the paint is still wet, the artist lifts out areas with a scrunched tissue to suggest clouds.

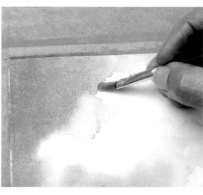

2. When the paint has dried, hard edges can be scrubbed and softened with a stiff-bristle brush. Dabbing the dampened edges with a tissue will lift out the loose paint.

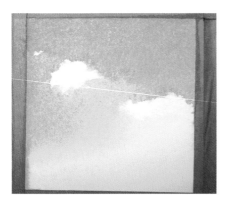

3. The final stage shows the wash when dry. Notice how the paint has seeped back into the dabbed-out clouds a bit, creating a soft edge.

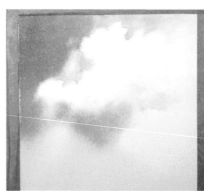

3. The finished cloudscape shows how the edges have been softened and blurred. This technique is useful to soften sharp edges in the background, to create an out-of-focus look, or to suggest something seen through glass.

Lifting out (wet) and adding colors

In this example, paint has been added to areas that have been lifted out. In order to create soft edges, the whole area must be re-wetted. A large wash brush is useful.

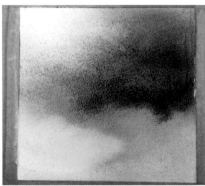

1. Colors are dropped onto wet paper and allowed to blend.

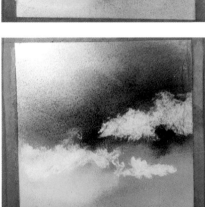

2. While still wet, a scrunched up tissue is used to lift out areas of cloud. The paint is then allowed to dry.

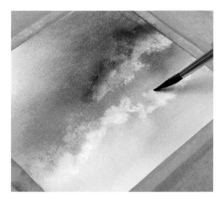

3. Once the paint has dried, the whole picture is re-wetted with a large brush and clean water. As the water begins to soak in, dark gray is painted along the upper edges of the clouds.

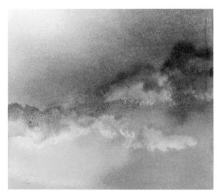

4. The effect is one of clouds lit from below. Note how watercolor always appears lighter when dry.

Drybrush

This technique involves using a dry brush to apply color onto dry paper or a dry layer of color. The rough, broken brushstrokes that result are great for adding texture.

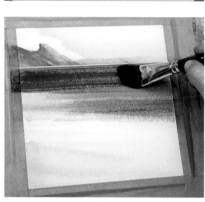
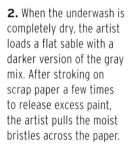

1. The artist prepares the base layers for a little seascape with gray (Winsor blue and Venetian red) and a little Naples yellow in the sand.

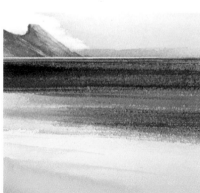

2. When the underwash is completely dry, the artist loads a flat sable with a darker version of the gray mix. After stroking on scrap paper a few times to release excess paint, the artist pulls the moist bristles across the paper.

3. The finished painting shows how the stroke has touched the "peaks" of the textured watercolor paper but skimmed over the "troughs," leaving a broken effect reminiscent of a gently rippling sea. This was done on cold-pressed paper; rough paper would have given a greater effect.

Scumbling

Usually done with a short-haired brush (the older the better), scumbling involves scrubbing dry paint unevenly over another layer of dry color so that the first layer shows through in parts.

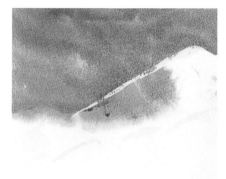

1. The edge of the mountain is covered with masking fluid and left to dry. The paper is dampened, and a wash of Antwerp blue with a touch of Payne's gray is laid. The color is lifted out where it floods over the mountain top.

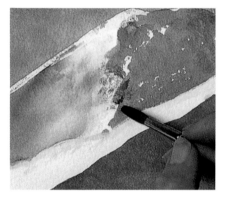

2. The shadows on the mountain are painted with a darker, grayer mix of the two colors used previously. When the paint is dry, dry sepia is scumbled on the exposed rock edges and used to pepper snow in the center.

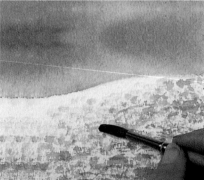

3. A diluted but dry mixture of Antwerp blue and Payne's gray is used to scumble the trampled snow in the foreground. Tone is built up by scumbling with the brush.

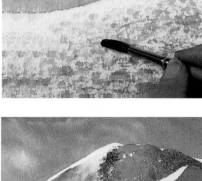

4. The masking fluid is carefully rubbed off and the white areas are dampened. A pale wash of Antwerp blue is applied for the shadows in the undulating snow.

Wax resist

Candle wax resists paint, so it acts as a masking fluid that cannot be removed. It is difficult to see where you've applied the wax, so you might have to tilt the painting under a light for easier viewing.

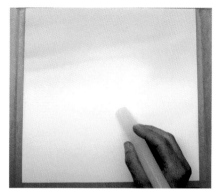

1. Over a loose but dry wash of cadmium yellow and Venetian red, the artist draws a path of sunlit water and some shoreline ripples with a white candle.

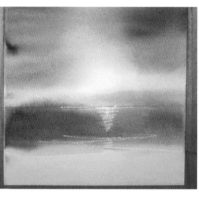

2. A subsequent wash of Winsor blue, Venetian red, and dioxazine violet reveals the candle marks.

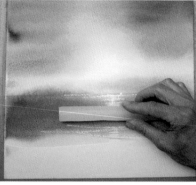

3. Laying the candle on its side, the artist drags it across the paper, applying firm pressure.

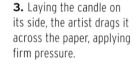

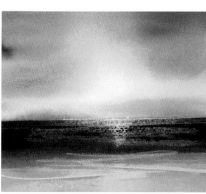

4. A darker wash of the sea color reveals the second layer of candle wax, giving texture and sparkle to the water.

Blossoms

Depending on the heat and humidity, watercolor will remain wet for some time. Drop water on the wet pigment to create blossoms of spreading color for visual interest.

1. The artist drops rose madder, dioxazine violet, Naples yellow, and Winsor blue onto wet paper and allows the colors to blend.

2. While the color is still wet, the artist drops clear water from a clean brush into the paint. The water carries the pigment to the edge of the droplet as it continues to spread.

3. Continuing the theme, the artist drops some dioxazine violet into the still damp rose madder and the Winsor blue, and then she sits back and watches them spread.

4. Once dry, the painting shows the blossoms and florets with the concentration of pigment around the edges. Smaller splashes have made smaller blossoms.

Spattering

Spattering is a technique in which paint is flicked off a brush by tapping the metal end of the brush handle against the finger, releasing a spray of paint. It lends itself particularly to foliage, as illustrated here.

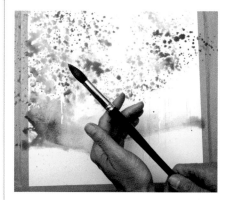

1. Sap green is gently spattered over a loose drawing of tree trunks, sections of which have been washed out to suggest dappled light.

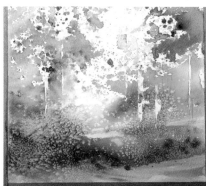

2. The same green is brushed loosely over the foreground, with areas of cerulean and dioxazine violet flooded in to suggest a carpet of bluebells. Salt is sprinkled in to add texture.

3. Tissues protect the foreground and sky from successive layers of spattering. More pigment is added at each stage to bring shadow and depth to the image.

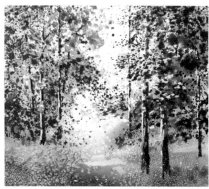

4. After all the spattered paint has dried, the tree trunks are painted with burnt umber and sap green.

Using salt to create texture

Table salt is one of the most effective ways to add texture with wet watercolor. The effects can be translated into different textures depending on the context in which it's used—snow, lichen, rocks, leaves, flowers, and so on. Timing will alter the effect, as illustrated below.

Spraying water

This is similar to dropping in clear water to create blossoms, but involves using a spray bottle or diffuser to achieve a much more subtle speckled effect.

1. Here salt is added to very wet paint, giving a softer and more diffuse effect.

2. In this example, the salt is added after the paint has dried a little—still damp, but not running.

3. Here the paint has almost dried; the effect is smaller and tighter.

1. The artist adds Naples yellow, rose madder genuine, Winsor blue, and Venetian red to wet paper and allows the colors to blend.

2. Timing is crucial—the effect is best when the paint is still damp but has just lost its surface sheen. At this point, water is sprayed from the bottle in short bursts.

3. The final picture shows that the bottom left-hand area was still too wet—the water droplets here have merged into the paint without leaving a mark. In the soft grays, however, a random pattern of tiny watermarks is visible.

Running in

This is a similar technique to creating blossoms, but this time the board is tilted to allow gravity to act on the paint.

1. A flat wash of Winsor blue mixed with a touch of Venetian red is laid down on the paper.

2. While it's still wet, the board is held upright and a brush holding clean water is touched to the top. The water runs down, carrying the pigment with it.

3. More drops of clear water are touched to the top of the still-wet paint.

4. Here the paint has dried, leaving soft-edged passages of lighter color within the wash.

Scratching out

Detail can be added using fine points, such as a dip pen to add fine lines or a sharp knife to scratch them out, as shown here.

1. A loose wash of olive green, sap green, and Naples yellow is laid down wet-in-wet to establish the base.

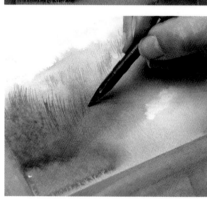

2. The artist uses a dip pen to make thin lines of green, adding texture and detail to the grass.

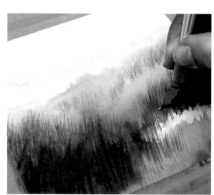

3. The tip of a sharp knife blade is used to scratch out the lines from a patch of light, highlighting blades of grass.

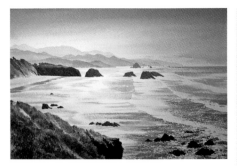

LIGHT BRIGHT DAY by Naomi Tydeman
p30–37

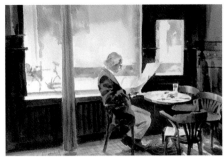

SIMPLE PLEASURE by Doug Lew
p38–45

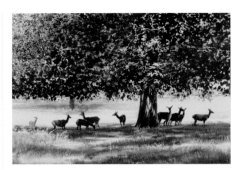

THE GATHERING by Naomi Tydeman
p46–53

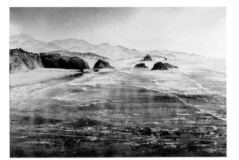

BRISK MORNING by Deborah Walker
p30–37

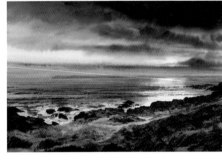

SUNDAY PAPERS by David Poxon
p38–45

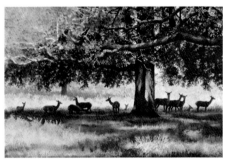

LADIES DAY by Mark Stewart
p46–53

Comparing

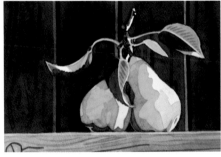

TWO PEARS ON A WOODEN SHELF by Marjorie Collins
p78–85

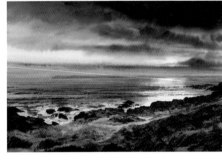

REMAINS OF THE DAY by Naomi Tydeman
p86–93

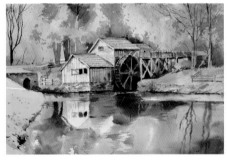

FALL COLORS–REFLECTION by Milind Mulick
p94–101

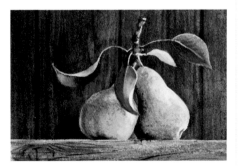

STUDY OF TWO PEARS by Naomi Tydeman
p78–85

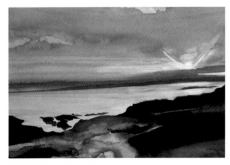

LAST LIGHT by Robert Tilling
p86–93

WOODLAND MILL by Steven Bragg
p94–101

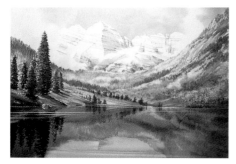

COME AUTUMN by Naomi Tydeman
p54–61

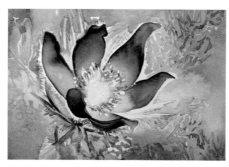

OPEN PASSION by Carol Carter
p62–69

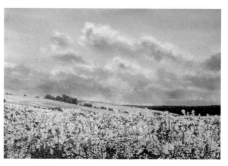

ATMOSPHERIC SKY by Jean Canter
p70–77

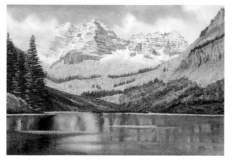

QUIET REFLECTIONS by Neil Barlow
p54–61

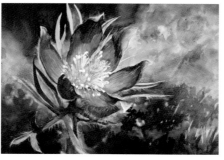

PURE ESSENCE by Karen Vernon
p62–69

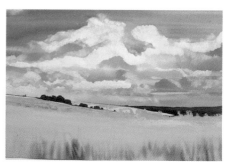

DISTANT FIELDS by Robert Tilling
p70–77

techniques

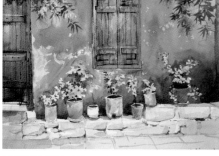

POTTED PLANTS by Milind Mulick
p102–109

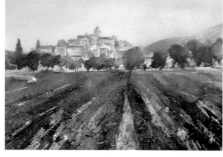

LAVENDER by Adrie Hello
p110–117

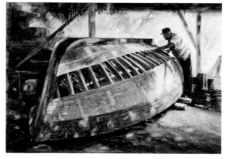

DAYS LIKE THESE by David Poxon
p118–125

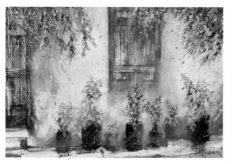

MEDITERRANEAN WALL by Adrie Hello
p102–109

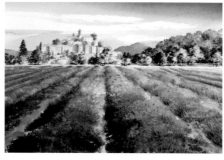

ROWS OF LAVENDER by Naomi Tydeman
p110–117

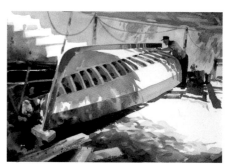

THE BOAT YARD by Doug Lew
p118–125

Seascape

In this scene, the light, rippling waves nicely contrast with the dark rocks, but the overall tones are too dark to work well in watercolor without becoming muddy. In this exercise, artists Naomi Tydeman and Deborah Walker take different approaches in lightening the tones and creating a more atmospheric scene.

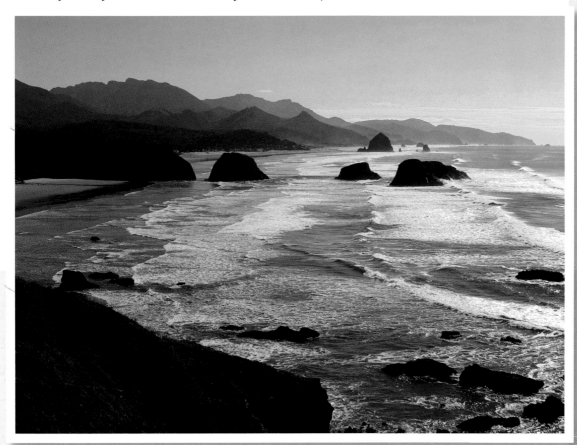

MAKING DECISIONS

Both artists take artistic license (the artist's right to alter the reference) with this scene, but they do it in different ways. Artist 1 lightens the overall tones but changes the colors from blue to orangey brown, imbuing the scene with a warm feeling. She also maintains the majority of the elements from the reference, especially the small rocks, which she sees as "punctuation marks" in the expansive sea. Artist 2 also lightens the tones but keeps the cool blue hues. She decides to completely omit the foreground and the rocks in the sea, instead focusing on patterns created by the waves. Both artists dramatically lighten the background, creating a greater sense of depth and atmosphere.

■ **Palette**
Winsor blue
Venetian red
Olive green
Burnt umber
Chinese white

■ **Materials**
Watercolor board
2B pencil
Masking fluid
2-inch (5-cm) flat brush
³/₄-inch (2-cm) flat brush
No. 5 round sable brush
Short-haired brush

■ **Techniques**
Masking out, page 21
Wet-on-dry, page 20
Graduated wash, page 19
Scumbling, page 24
Spattering, page 25
Lifting out (wet), page 22
Drybrush, page 23

■ **Palette**
Winsor blue
Payne's gray
Caput mortuum
Rose madder
 genuine
Raw sienna

■ **Materials**
Sketch paper
Watercolor paper, cold-
 pressed
Fine-line pen
Masking fluid
Shaper
3-inch (7.5-cm) flat brush
No. 14 round sable brush
Bamboo dip pen (see
 page 33)
Bristle brush

■ **Techniques**
Masking out, page 21
Variegated wash, page 19
Wet-in-wet, page 20
Wet-on-dry, page 20
Lifting out (wet), page 22
Drybrush, page 23
Spattering, page 25

1 ARTIST 1:
Naomi Tydeman

Artist 1 draws the scene directly on the watercolor board, lightly sketching the distant coastline and using heavier marks for the rocky outcrop in the foreground so its outline will show through several layers of washes.

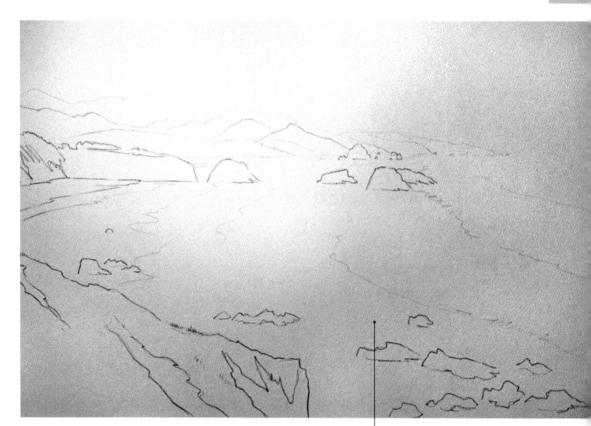

Very little detail is drawn into the surf to allow for more freedom in the brush marks.

1 ARTIST 2:
Deborah Walker

Artist 2 makes a small line drawing on sketch paper with a fine-line pen to work out the composition before beginning the painting. She then makes a very light drawing on the watercolor paper to give herself a guide for applying the masking fluid, which will describe the broken, sparkling surface of the water and the lines of the waves.

MASKING
Using a shaper, Artist 2 applies masking fluid with a combination of drawn lines and spattering over the surf.

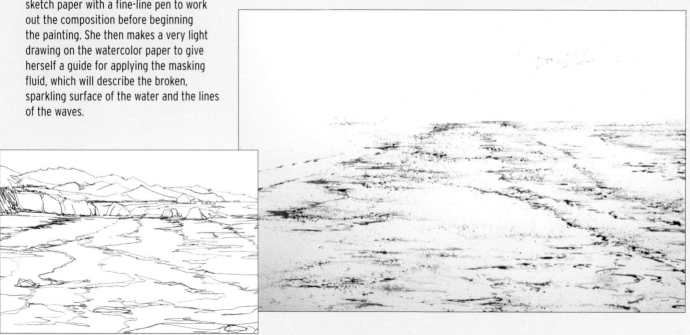

The headland and small rocks are omitted from the sketch.

2 FIRST STAGES

Artist 1 masks out the areas of light in the bottom right-hand corner, drawing and spattering in the sparkling water and surf where the tone is darkest and the contrast greatest. She maps out the distant headland by applying washes made up of Winsor blue and a little Venetian red.

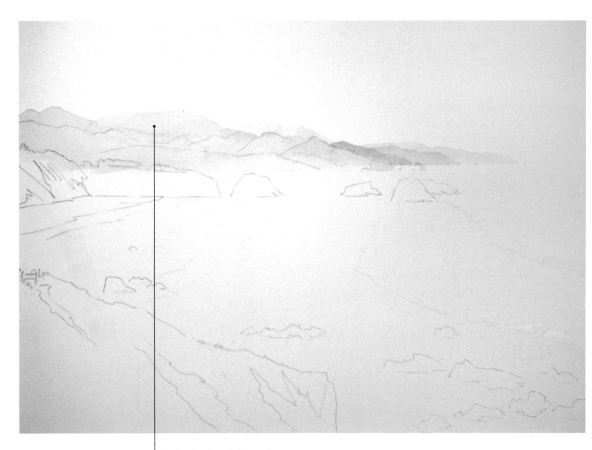

The headlands are built up with successive layers of paint applied wet-on-dry.

2 LIGHT AND ATMOSPHERE

After mixing a generous wash of Winsor blue and caput mortuum, Artist 2 wets the paper with the 3-inch (7.5-cm) flat brush and then floods in the color. She washes in touches of rose madder genuine and raw sienna around the clouds, beach, and distant horizon. Passages of light are lifted out of the sea using a damp brush.

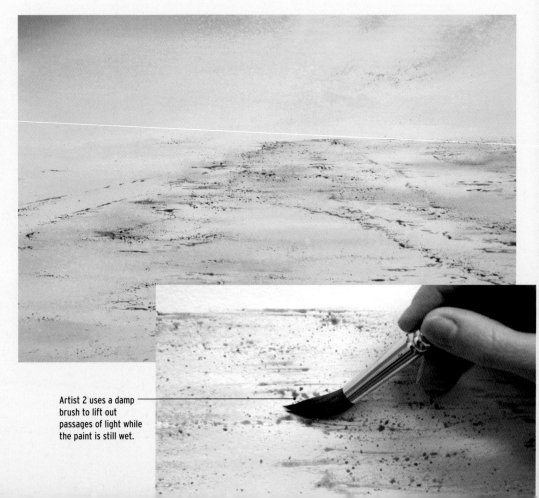

Artist 2 uses a damp brush to lift out passages of light while the paint is still wet.

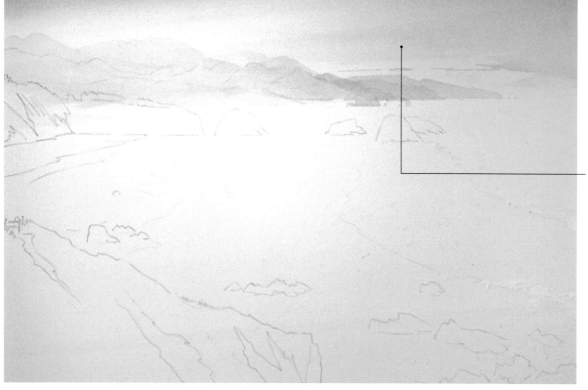

Cloud shapes are made by lifting out some of the blue with a damp brush.

3 **SKY**
Artist 1 loads the 2-inch (5-cm) flat brush with the same diluted blue wash used for the distant headland and floods the sky, as shown. She paints another flat wash over the hills and distant headland to soften them and make them recede into the background. Tilting the board at a slight angle so the paint flows downward, she adds more water or pigment as required.

3 **HEADLAND PENINSULA**
Artist 2 works from the distant mountains to the nearest rocks with increasingly darker washes of the Winsor blue and caput mortuum mix. She paints the jutting headland with the No. 14 round sable brush. Warmer tones of raw sienna and caput mortuum are applied to the peninsula just beyond the nearest headland.

A bamboo pen, which creates a softer line than a metal-nibbed pen does, is dipped into Payne's gray and used to add details and shadows to the nearest headland.

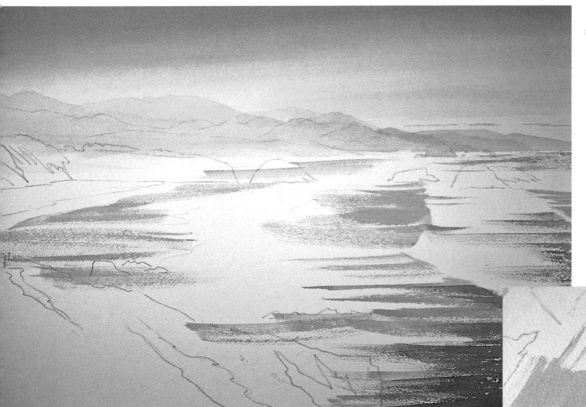

4 SEA AND WAVES
Artist 1 proceeds to use the same diluted wash of the sky and headlands for the sea, gradually intensifying it as she works her way toward the foreground to paint the breakers rolling in. Using the ³/₄-inch (2-cm) flat brush, she changes the angle of the brush to vary the width of her brushstroke in accordance with its relationship to the horizon. Notice the narrower sweeps in the distance and the wider sweeps in the foreground.

The sea is painted in a series of short drybrush strokes. Starting at the base of a breaker, the brush is dragged quickly to the left and then lifted before reaching the crest of the wave.

4 SEA
Artist 2 dampens the sea and works in a more intense mix of Winsor blue and caput mortuum, using the surf patterns created by the masking fluid. Holding up the sheet of paper vertically to allow the pigment to run down, she drops water into the paint with the tip of the No. 14 round sable brush.

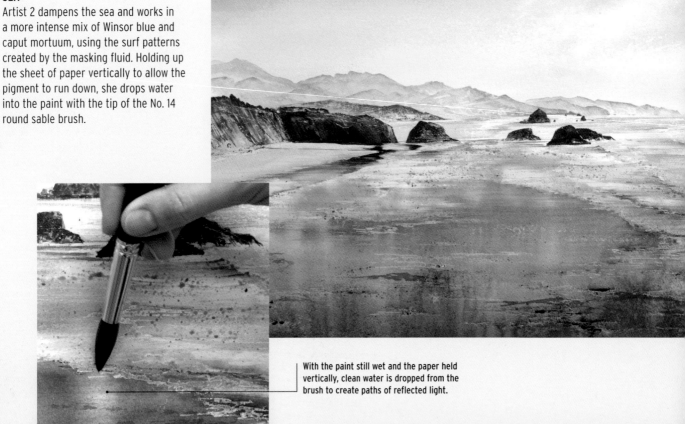

With the paint still wet and the paper held vertically, clean water is dropped from the brush to create paths of reflected light.

5 ROCKS AND HEADLAND
Using slightly stronger washes applied with a No. 5 round sable brush, Artist 1 blocks in the mountains and distant rocks, thinning out the wash at the base of each layer to suggest mist or haze. She introduces olive green and burnt umber to the middle-ground peninsula for warmth and color. The rocks at the base of the cliff face are painted with the same mix of Winsor blue and Venetian red but with very little water added.

A stronger wash is used for the headland just in front of the misty hills, and rough, broken strokes are made at the base of the rock formations to suggest the surf.

5 ADDING DEPTH
Adding more pigment to the Winsor blue and caput mortuum mix, Artist 2 uses wet and dry brush marks, variegated lines and streaks, spatterings, and flicks of the brush to gradually add texture to the water's surface. Dark shapes in the foreground begin to suggest submerged rocks. She dampens the sky once again and drops more color into the top left-hand corner of the picture for a heightened sense of atmosphere.

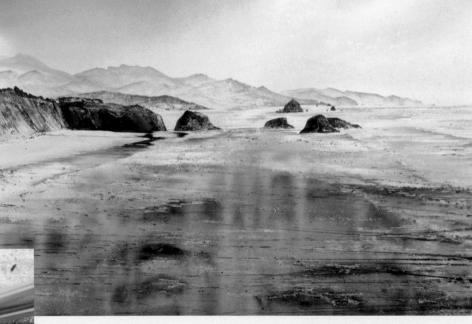

Intense color is applied wet-in-wet to increase the depth and contrast within the sea.

FINISHING TOUCHES
Overlaying several washes of olive green and burnt umber, Artist 1 works into the foreground cliff with short scumbling strokes using an old, short-haired brush. With the painting now virtually finished, she removes the masking fluid from the bottom right-hand corner of the painting. The sunlight on the water still lacks sparkle, so she mixes some Chinese white with a little water and adds more detail to the surf.

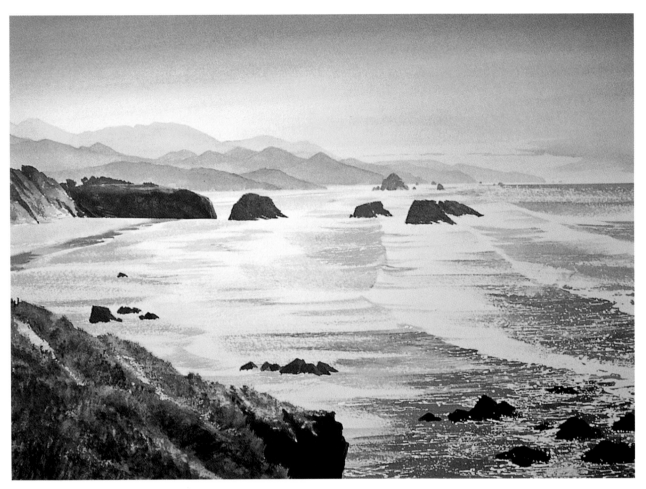

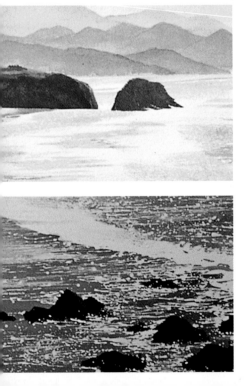

Horizontal drybrush strokes give texture to the surf.

Chinese white is spattered onto dark water, creating sparkle.

LIGHT BRIGHT DAY (15 X 22 IN/38 X 56 CM, WATERCOLOR ON WATERCOLOR BOARD)

"There is a lot of empty space in this picture. Most of the interest is either small scale or distant, and you wonder how to fill up the piece of paper. It's all light and air and bubbles in water, so I painted everything that wasn't and hoped that's what I'd be left with—light and space."
Naomi Tydeman

FINISHING TOUCHES

Artist 2 removes the masking fluid to reveal the white paper that creates the highlights on the breaking waves. Finally, after spattering on more paint and softening some of the darker edges with a damp bristle brush, she convincingly pulls together the surface texture of the water.

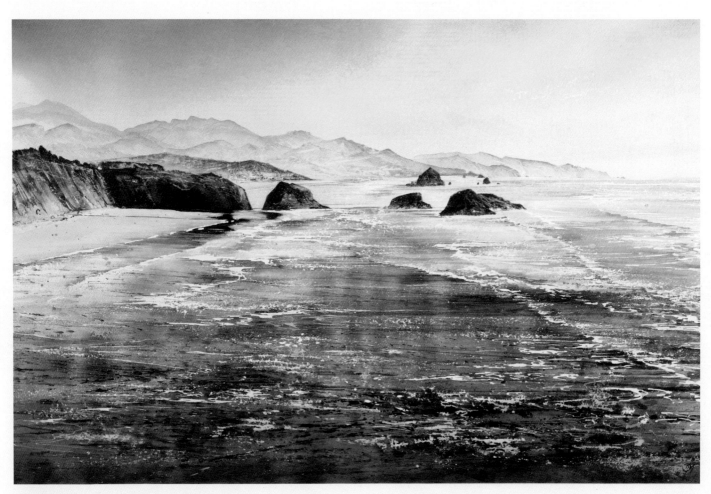

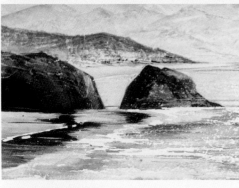

The dark reflections make the sand appear wetter.

BRISK MORNING (19 X 29 IN/48 X 74 CM, WATERCOLOR ON COLD-PRESSED WATERCOLOR PAPER)

"I wanted to give the viewer a sense of light, space, and a cool breeze coming off the sea."
Deborah Walker

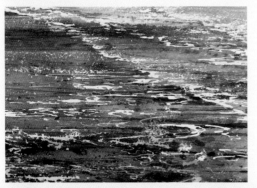

Textures created by masking fluid emulate patterns on the surface of the water.

COMPARING THE WORKS

Although very different, both paintings capture the feeling of space and light successfully. Artist 1 has departed radically from the color scheme of the reference image, warming the colors throughout the painting. Artist 2 has retained the overall blue theme, using a very limited palette of colors, but has brought in touches of green and yellow-brown on the distant hills.

Café interior

This intimate scene is a wonderful example of extreme contrasts between light and dark. The eye is drawn to areas of contrast, so it's important to strategically place darks, lights, and color to determine a focal point. Here artists Doug Lew and David Poxon use different methods to attract the viewer's eye.

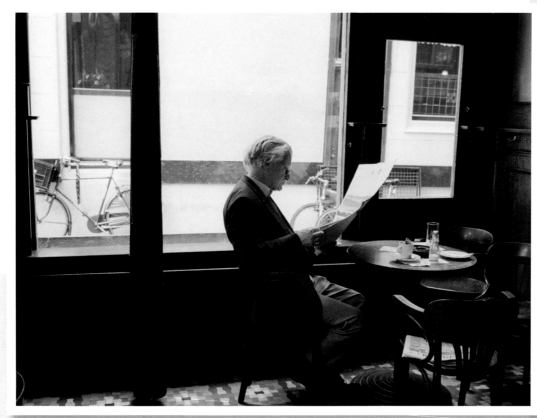

Palette
Raw sienna
Burnt sienna
Sap green
Indigo
Burnt umber

Materials
Watercolor paper, rough
4B pencil
No. 10 round sable brush
No. 4 bristle brush
Flat wash brush

Techniques
Wet-on-dry, page 20
Wet-in-wet, page 20
Lifting out (wet), page 22

Palette
Yellow ochre
Manganese blue
Cerulean blue
Burnt sienna
Permanent blue
Alizarin crimson
Burnt umber

Materials
Watercolor paper, cold-
 pressed
2B pencil
Masking fluid
Old brush handle
½-inch (1.3-cm) flat wash
 brush
No. 10 round sable brush
Fine brush
Bristle brush
Tissue

Techniques
Masking out, page 21
Wet-in-wet, page 20
Glazing, page 21
Wet-on-dry, page 20

LIGHTS AND DARKS

The placement of light and shadow, as well as color, is essential to a successful composition. In this lesson, Artist 1 uses a limited palette of five colors to convey the scene, lightening the overall tones but maintaining contrast between light and dark. In the photo, the curtain and chairs are almost completely in shadow, but Artist 1 makes them lighter, which draws the eye to them immediately. Artist 2 also lightens the tones but keeps the curtain and furniture in shadow—these dark areas contrast with the lighter colors on the figure, which then becomes the focal point.

1 **ARTIST 1:**
Doug Lew

Artist 1 uses a 4B pencil to make a simple yet precise outline drawing directly onto the watercolor paper. He concentrates on pinning down more detailed elements on the right-hand side of the painting.

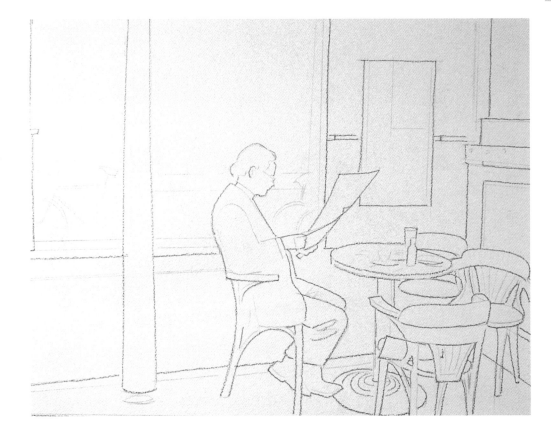

1 **ARTIST 2:**
David Poxon

Artist 2's sketch concentrates on the man's profile, figure, posture, and hands—all of which are vital to getting the painting right. He makes several sketches before finally deciding on the composition. He then begins with a line drawing, indicating a few key areas of tone.

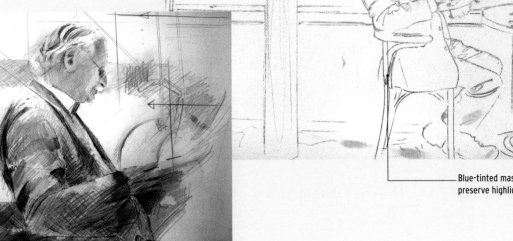

Blue-tinted masking fluid is used to preserve highlights.

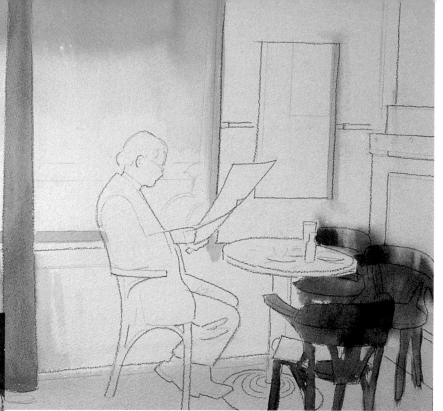

2 FIRST WASHES
Feeling that the stark white of the window will be too overwhelming, Artist 1 washes a light tone of indigo over it. He then lays a light tone of burnt sienna across the floor and a darker shade of the same color over the curtain and chairs.

A clean bristle brush is used to lift out highlights from the still-damp paint and give shine to the polished wood of the chairs.

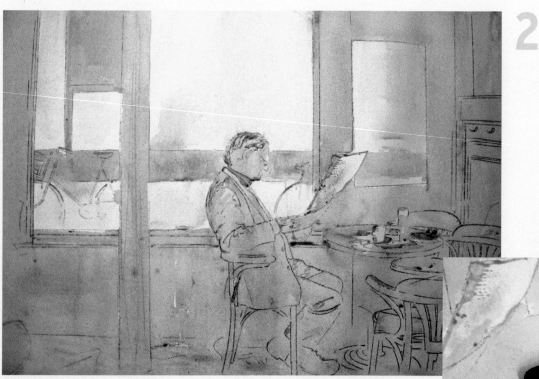

2 BLOCKING IN MID-TONES
Artist 2 loosely floods the paper with mixtures of yellow ochre and manganese blue, avoiding the window area, elements on the table, and part of the newspaper. He tilts the board at different angles to allow the paint to flow in the direction he wants. This also encourages the sediment in the manganese blue pigment to precipitate, producing a granular texture.

A ½-inch (1.3-cm) flat brush is used to lay down the initial wash, and allow the paint to flow around the masked highlights.

3 **JUDGING TONES**
The back and side walls are dark in tone, but Artist 1 decides to lighten the right-hand wall and the top left-hand corner to create more variety and harmonize with the lighter curtain and furniture. He loads up the No. 10 round brush and paints the whole area with burnt sienna, blending in a dark wash of burnt umber before this has fully dried. All other tones will sit between these two tonal extremes: the dark walls and the light-flooded window.

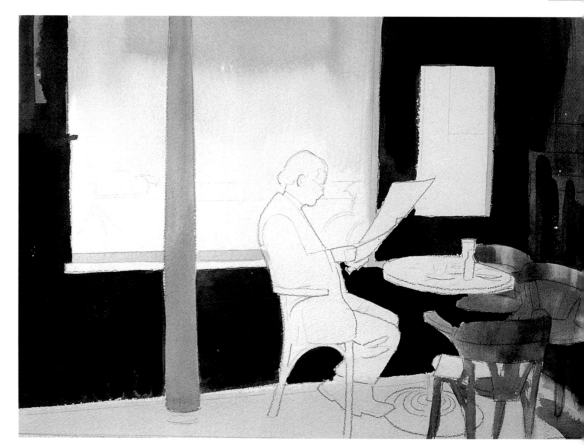

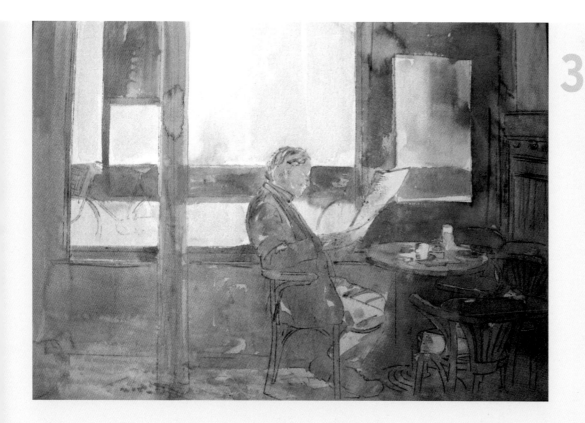

3 **BUILDING UP LAYERS**
Artist 2 applies two more thin glazes of yellow ochre and manganese blue, wet-on-dry, increasing the density of the tones. Then he floods the first tints of local color into the right-hand side using varying amounts of burnt sienna and alizarin crimson.

4 MIDDLE VALUES
Artist 1 blocks in the man's clothing with a mix of indigo warmed up by a touch of burnt sienna. Then he details the furniture, introduces cast shadows to define the wood paneling, and paints the folds of the curtain. A diluted wash of burnt and raw sienna is used to block in the head.

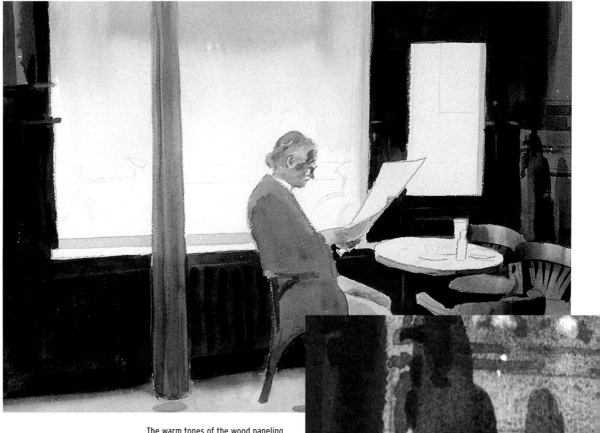

The warm tones of the wood paneling show loose but intricate detailing.

The reflections from the polished table and glass are added before the masking fluid is removed.

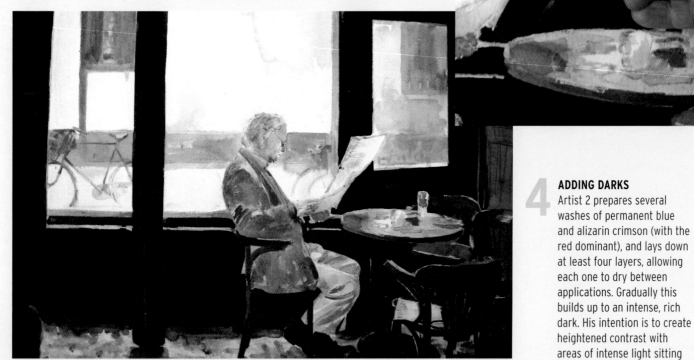

4 ADDING DARKS
Artist 2 prepares several washes of permanent blue and alizarin crimson (with the red dominant), and lays down at least four layers, allowing each one to dry between applications. Gradually this builds up to an intense, rich dark. His intention is to create heightened contrast with areas of intense light sitting alongside very dark passages.

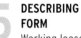

DESCRIBING FORM

Working loosely, Artist 1 indicates the folds and creases of the man's clothing in darker tones of the same indigo wash to give him a three-dimensional presence.

This detail from the man's jacket shows the effect of overlaid washes worked wet-on-dry.

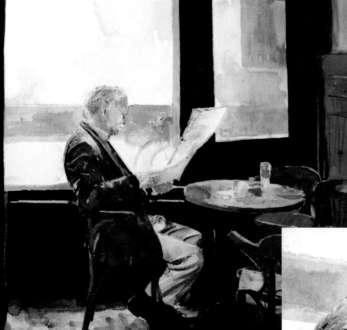

DEFINING DETAILS

Once the correct tones have been identified, Artist 2 tightens the composition by redefining some edges and softening others with a bristle brush and clean water. To accentuate the highlights on the man's head, he adds an extremely diluted wash of yellow ochre and cerulean blue to the windowpane.

A very fine brush is used for the edges of clothing.

FINISHING TOUCHES

After wetting the window area with clean water so that the colors blend wet-in-wet, Artist 1 creates the details of the street outside using varying mixes of indigo, sap green, and raw sienna. This treatment produces a diffuse effect that allows the subject to recede into the background. Artist 1 connects the painting's two halves by adding a band of blue-gray and working some final detail into the floor.

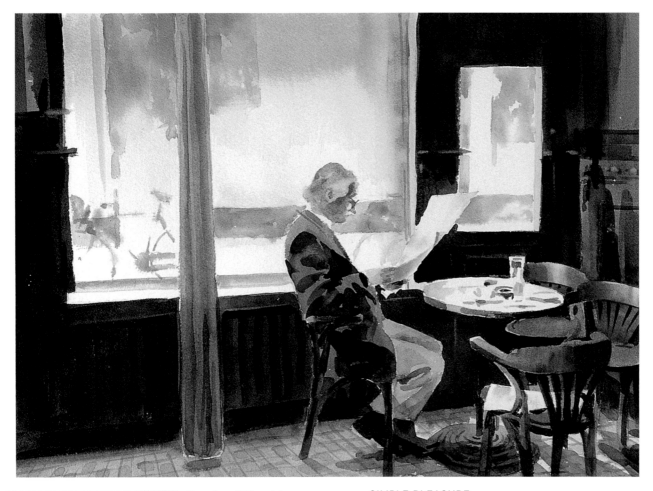

To avoid the paint running too much, the paper is allowed to dry a little before the bicycle is painted.

Keeping the details on the table light and gestural adds to the impressionistic feel.

SIMPLE PLEASURE
(12¼ X 14¼ IN/31 X 36 CM, WATERCOLOR ON ROUGH WATERCOLOR PAPER)

"I approached this painting with an overall suggestive feeling...not dwelling on any details in photo-like realism. A large use of wet-in-wet was applied for things outside the window to give it the watercolor look."

Doug Lew

FINISHING TOUCHES

Using a bristle brush, clean water, and a tissue, Artist 2 softens some of the hard edges produced where the pigment has collected against the reserved areas. He blends in the subtle tones of the clothing to create soft folds in the fabric, leaving the sharp shadows of the objects on the table untouched. He finishes the painting with a few smudges of light lifted out from the glass, and one final glaze over the darkest tones.

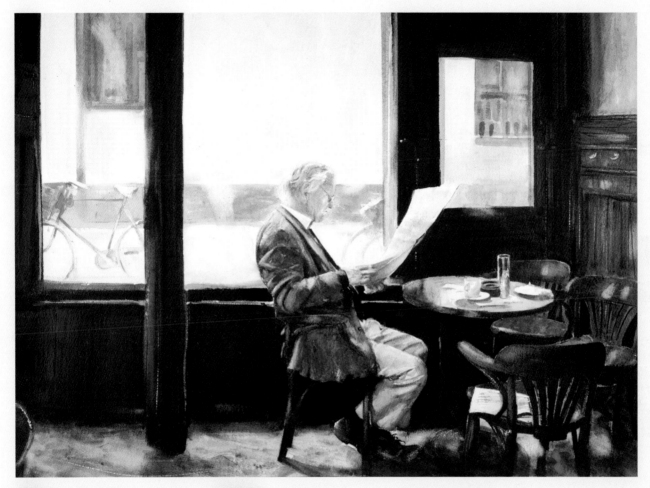

Lifting out some color with a damp tissue smudges the objects beyond the window and makes them recede.

Careful attention to shadow and reflection enhances the forms of the objects on the table.

SUNDAY PAPERS

(18 X 25 IN/46 X 64 CM, WATERCOLOR ON COLD-PRESSED WATERCOLOR PAPER)

"I wanted to retain the quietness and relaxed atmosphere of this peaceful Sunday morning scene, so I adopted a patient multilayered approach to the work in pure watercolor."
David Poxon

COMPARING THE WORKS

Both paintings are full of atmosphere and describe the subject with great accuracy, but Artist 1's gives a softer impression due to the use of wet-in-wet methods. Artist 2 has worked wet-on-dry throughout, building up the tones in a series of layers to produce rich darks and crisp, clear edges.

Woodland deer

In this serene landscape, the tree and deer are of equal importance—both are in shadow and set back into the picture at about the same distance. To capture the scene effectively in watercolor, artists Naomi Tydeman and Mark Stewart must create a clear focal point and introduce visual cues to lead the viewer's eye to the center of interest.

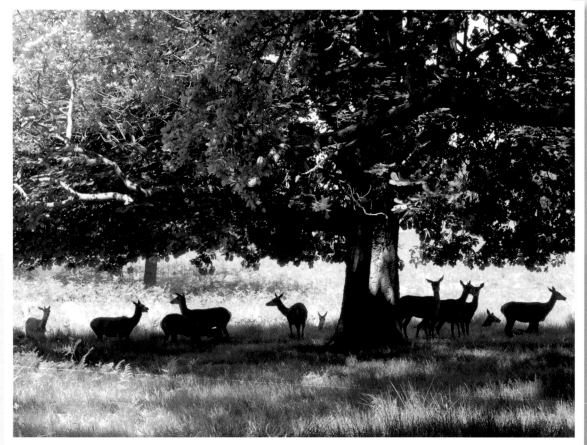

CHOOSING A FOCAL POINT

A pleasing composition needs to have a strong focal point. As this photograph lacks a clear center of interest, both artists must elevate the importance of a particular element to make it stand out. Artist 1 chooses to make the deer more prominent by lightening their tones and setting them against a wide band of sunlight. She also introduces brighter patches in the grass to lead the viewer's eye to the deer. Artist 2 chooses to focus on the tree, bringing it forward in the picture plane and painting it with more detail. The deer are still important, but the contrast of light and shadow on the tree trunk draws the viewer's eye there first.

■ **Palette**
Olive green
Burnt umber
Winsor lemon
Winsor blue

■ **Materials**
Watercolor board
Dip pen
Masking fluid
2B pencil
Old brush
No. 5 and No. 10 round sable
brushes

■ **Techniques**
Masking out, page 21
Spattering, page 25
Wet-on-dry, page 20
Lifting out, page 22
Drybrush, page 23

■ **Palette**
Sap green
Cadmium yellow
Cerulean blue
Winsor green
Brown madder
Burnt umber
Raw umber
Sepia

■ **Materials**
Watercolor paper, hot-
pressed
HB pencil
Sharp knife
1-inch (2.5-cm) flat brush
No. 3, No. 6, and No. 8
round sable brushes

■ **Techniques**
Wet-in-wet, page 20
Wet-on-dry, page 20
Scratching out, page 27
Drybrush, page 23

1 ARTIST 1:
Naomi Tydeman

Artist 1 sketches the scene with a 2B pencil directly on the watercolor board. She pays particular attention to the shape and delicacy of the deer and the position of the tree trunk but leaves everything else to chance. Artist 1 chooses to omit the deer lying down in the grass and the deer in the far distance.

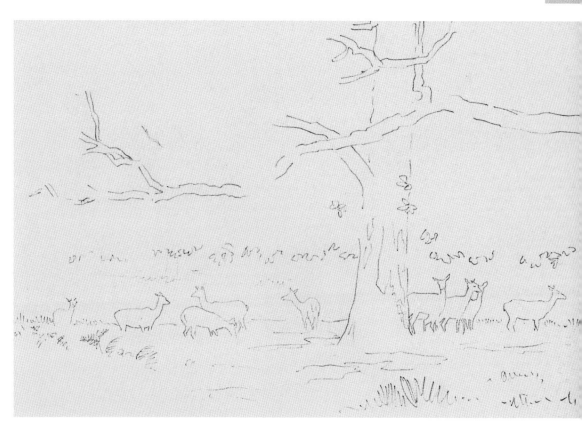

The artist uses a 2B pencil quite firmly so the lines will show through several layers of paint.

1 ARTIST 2:
Mark Stewart

Artist 2 makes a fairly precise sketch to work out the position of the elements. Then he makes a loose pencil drawing on the watercolor paper with an HB pencil, paying attention to the position of the deer in shadow, the larger branches, and the tree trunk.

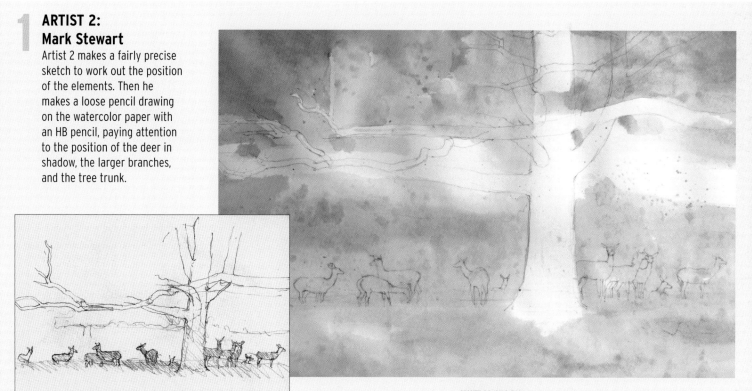

The key compositional elements are sketched in.

INITIAL WASH
Leaving some areas white, Artist 2 lays down an initial wash of sap green and cadmium yellow. Then he floods the sky with a pale cerulean blue.

2 MASKING OUT DETAILS

With the dip pen, Artist 1 masks out fine lines for the foreground ferns and grasses, then masks the areas of sunlight on the trunk and branches with an old brush.

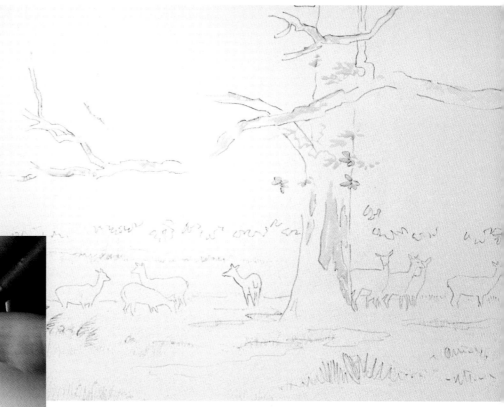

A pen allows fine lines to be made with masking fluid.

To make irregular and dappled leaf shapes, the artist presses the paint into the paper with his fingertips.

2 TEXTURES

When the first washes are dry, Artist 2 adds texture to simulate the sunlit leaves fluttering in the breeze. He spatters on a slightly stronger wash of sap green and cadmium yellow and makes marks on the paper using his fingers.

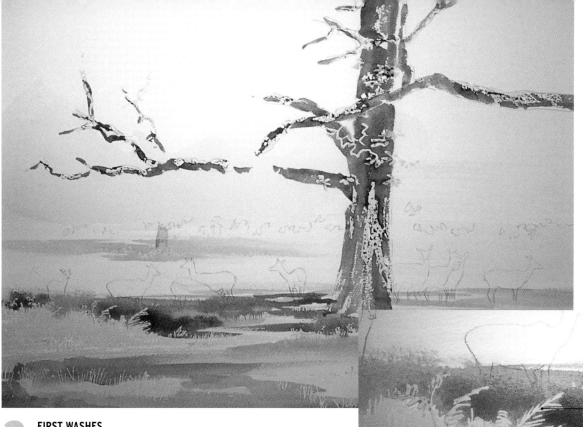

The close-up demonstrates how the sunlit ferns will show up against the shadows.

3 FIRST WASHES

Artist 1 mixes an olive green wash with a touch of burnt umber and loosely brushes this over the grass and the tree's shadow. With the same mix, she also marks the position of some of the branches and the trunk.

3 FOLIAGE

To achieve texture in the tree trunk and branches, Artist 2 "splays" the bristles of a new No. 8 sable brush and applies burnt umber drybrush strokes. Using No. 6 and No. 3 sable brushes, Artist 2 works detail and structure into the foliage. Winsor green and brown madder are added to the original sap green and cadmium yellow mix for the darker and cooler passages. Artist 2 does not use masking fluid and develops all texture and detail with his brushes.

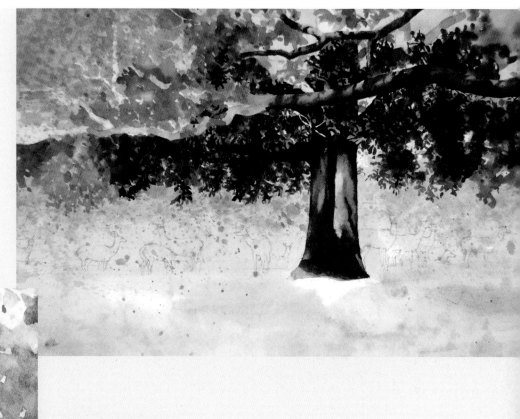

Highlights are accentuated on the branches by working around their outlines with darker colors.

The artist flicks paint onto the foliage by knocking the metal end of the brush handle against her finger. Tissue protects other areas.

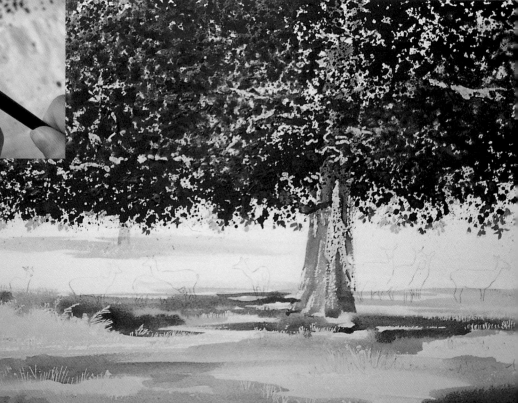

4

FOLIAGE

Artist 1 prepares several olive green washes: some strong, some diluted, some with a touch of Winsor lemon, and some darkened with Winsor blue and burnt umber. Placing tissues over the lower half of the painting to protect the foreground, she spatters on the paint, applying lighter tones to the top left and darker shadows underneath and to the right.

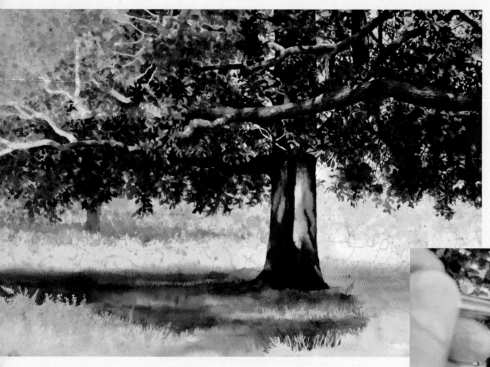

4

FURTHER DEFINITION

Artist 2 builds up and defines the tree trunk and branches using a combination of burnt umber, raw umber, and sepia with touches of cerulean blue. Varying the amounts and densities of these colors allows him to achieve light, dark, warm, and cool areas. Then he paints dark greens in the area of shadow.

The tip of a No. 6 sable brush is used to paint the leaves and bark.

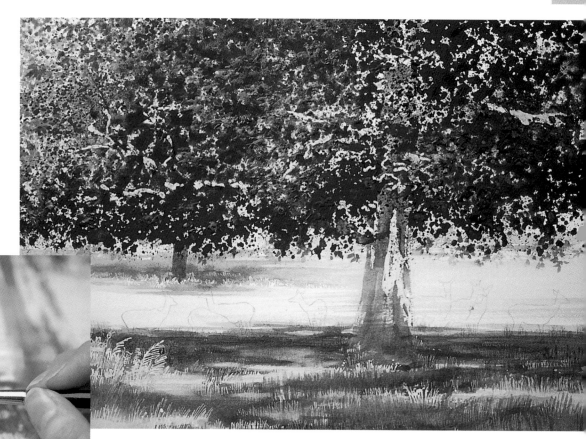

5 GRASSES
Artist 1 uses the dip pen to mask out more of the grass and ferns over the initial green wash. When this is dry, she brushes on another layer of olive green, repeating this process several times. She then removes all the masking fluid.

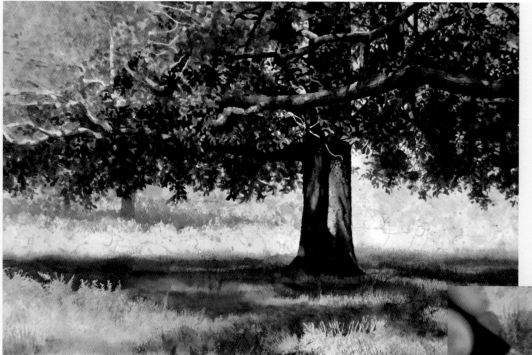

Some of the harsher grass areas are softened with the No. 5 round sable brush and a light green wash.

5 FOREGROUND GRASSES
Following another wash of green in the foreground, Artist 2 leaves the areas of sunlight and works texture into the grass by drybrushing dark paint up into a light area to create fine blades of grass.

When the paint is dry, the blade of a sharp knife is used to create lighter blades of grass within a dark passage.

FINISHING TOUCHES

Artist 1 paints the deer with the No. 5 round sable brush and a mix of burnt umber, Winsor blue, and a touch of olive green. She then removes masking fluid from the trunk and the branches. Detail is added to the darker areas curving over the branches and some shadows are deepened, some leaves are sharpened, and some edges are softened.

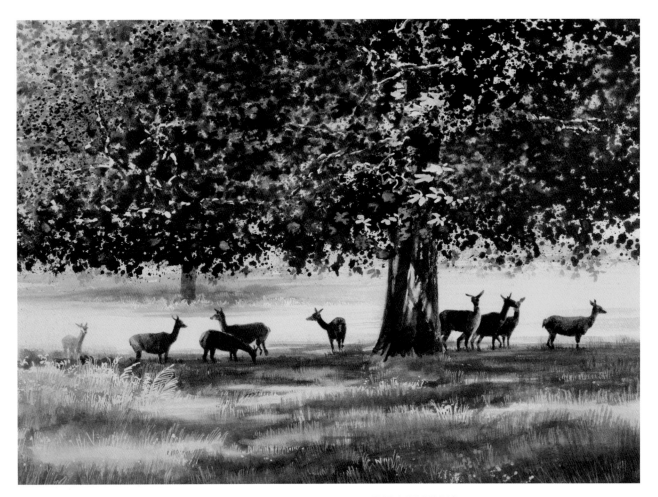

Spattering gives a loose and random look to the foliage.

Masking fluid provides a clear and well-defined edge, but the lines will be as thick as the instrument with which it is applied.

THE GATHERING
(15 X 22 IN/38 X 56 CM, WATERCOLOR ON WATERCOLOR BOARD)

"Woods and trees are a favorite recurring theme of mine. I love getting involved in creating dappled light and flickering shadows."
Naomi Tydeman

FINISHING TOUCHES

Artist 2 paints the deer using different mixes of burnt umber, cerulean blue, and brown madder. Their dark tones echo those of the branches, tying together the composition.

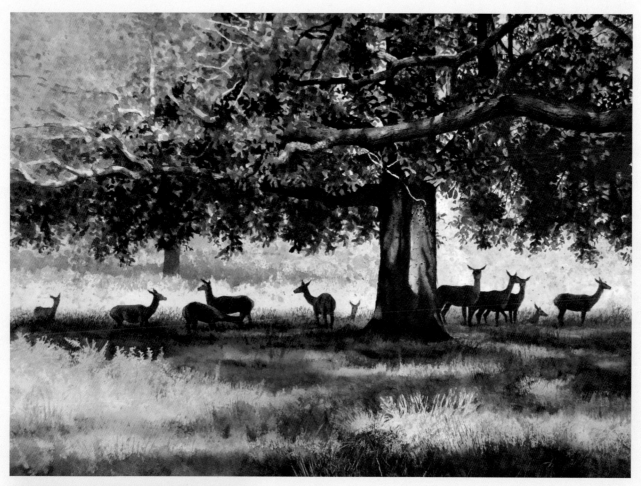

A careful approach gives the tree structure and form.

Using the tip of a sharp knife gives a finer and more natural look to the grasses.

LADIES DAY (15 X 18 IN/38.1 X 45.7 CM, WATERCOLOR ON HOT-PRESSED WATERCOLOR PAPER)

"Capturing the essence of the setting was challenging. Even if the grass blades look slightly unnatural, this type of painting can be successful if the lighting and shadows work. I think I achieved this in the way the light is portrayed in the tree's structure and the way that light dances off the ground."

Mark Stewart

COMPARING THE WORKS

The artists used different methods to create a lovely impression of dappled light and shade. Artist 1 used masking and spattering, whereas Artist 2 reserved the light areas of the foliage and small branches by painting around them, a method called "negative painting."

Rocky mountain

When painting a landscape scene such as this, it is vital to convey a sense of atmosphere and space. Artists Naomi Tydeman and Neil Barlow both take this into consideration when painting the same scene, but each makes different compositional decisions that radically alter the final results.

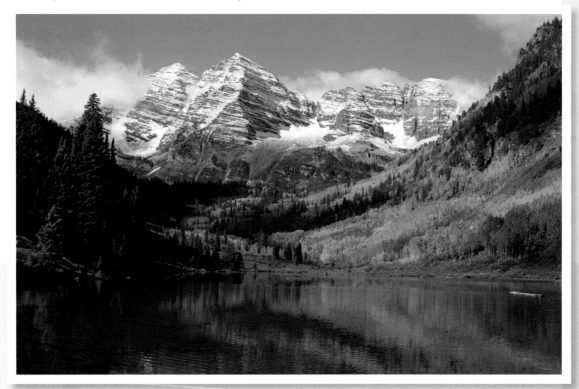

CREATING SPACE
There are two main ways to employ atmospheric perspective in a painting: one is making elements in the foreground more detailed than those in the background, and the other is making distant objects appear cooler and bluer and foreground objects warmer and brighter. Artist 1 employs the first method, detailing the foreground and making the mountains almost indistinct. Artist 2 uses the second approach, using cool blues to push the mountains into the distance and warm oranges and reds in the foreground to make it advance toward the viewer.

■ **Palette**
Winsor blue
Venetian red
Sap green
Quinacridone gold

■ **Materials**
Watercolor board
HB pencil
Dip pen
Ruler
Bristle brush
2-inch (5-cm) flat wash
 brush
No. 5 and No. 10 round sable
 brushes

■ **Techniques**
Wet-on-dry, page 20
Wet-in-wet, page 20
Drybrush, page 23
Lifting out, page 23

■ **Palette**
Aureolin yellow
Yellow ochre
Ultramarine blue
Cobalt blue
Light red
Burnt sienna
Burnt umber
Quinacridone gold
Winsor green

■ **Materials**
Watercolor paper, rough
Sketch paper
Masking fluid
No. 2, No. 4, and No. 7
 round sable brushes
Mop brush
1-inch (2.5-cm) flat sable
 brush
Tissue

■ **Techniques**
Masking out, page 21
Wet-in-wet, page 20
Wet-on-dry, page 20
Drybrush, page 23
Lifting out, page 23

ARTIST 1:
Naomi Tydeman

Artist 1 decides to use a full sheet of watercolor board to represent the vastness of the scene. She uses an HB pencil to sketch the basic outlines, merely indicating the shape of the mountains and the position of the lake and trees in the foreground.

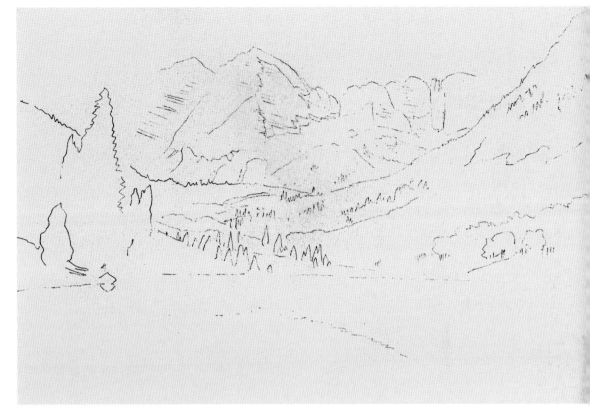

ARTIST 2:
Neil Barlow

Sensing that too much fine detail could detract from the scene's inherent natural power, Artist 2 decides to simplify the sketch's middle ground and reduces the number of trees on the lake's left bank. His sketch explores the main shapes; he does not engage with the reflections at this stage.

The composition is worked out on a piece of sketch paper.

SKY

After masking out the edges of the mountains, Artist 2 mixes a wash of ultramarine and cobalt blue for the sky, followed by ultramarine and light red for the clouds. Wetting the sky area thoroughly, he paints in the clouds and adds blue around them wet-in-wet.

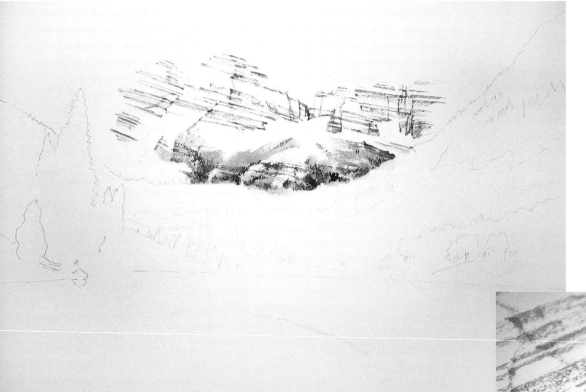

2 MOUNTAINS

Using a warm mix of Winsor blue and Venetian red, Artist 1 lightly drybrushes the rock strata of the mountains. After painting the loose rocks on the slopes with the same wash, she adds a little sap green and, with the point of the brush, marks in the tiny faraway trees.

The No. 5 round sable brush is held at a slight angle and dragged across the watercolor board's surface in parallel lines. This gives the effect of a rock face speckled with snow.

2 MOUNTAINS

Warming the sunlit snow with a diluted wash of aureolin and allowing it to dry, Artist 2 then adds the shadows wet-on-dry. He uses the ultramarine and light red wash to build up the rock face and slopes.

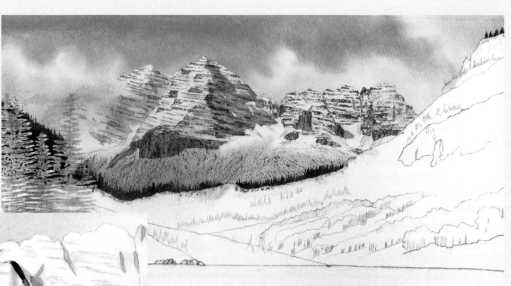

The rock formations are painted using fine drybrush strokes of the No. 2 round sable brush with a strong mix of the gray cloud wash.

3 SKY AND SHADOWS

Feeling that the blue of the sky in the photo is too intense, Artist 1 keeps to the Winsor blue/Venetian red mix, but adds more blue. Using the No. 5 round sable brush to delineate the edge of the mountains and the 2-inch (5-cm) flat brush to block in the sky, she works quickly to keep the paint flowing. She softens the clouds by blending water along the edges.

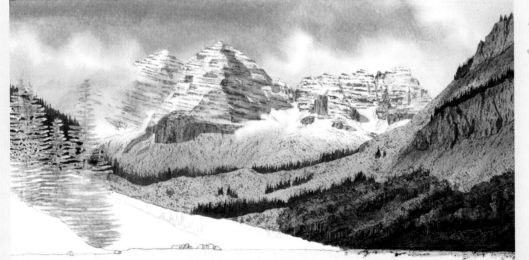

Shadows are painted with the same color as the sky, with some drybrush strokes creating transitional areas.

3 MIDDLE DISTANCE

Artist 2 creates the rich fall colors with a mixture of yellow ochre and a little burnt sienna. He needs to have these colors in place before working on the foreground. He then overlays some drybrushed burnt sienna for added texture. The form of the cliff face is painted using a denser wash of ultramarine and light red.

Quinacridone gold, aureolin, and burnt sienna are used for the color variations of the trees that are closer to the lake.

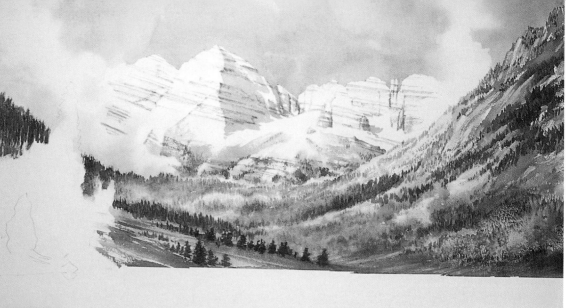

4 MIDDLE GROUND
Artist 1 works the fall hues of the middle ground and its woodland in various blends of Venetian red, sap green, and quinacridone gold. Working wet-on-dry and wet-in-wet, the paint is allowed to bleed to create filigree edges and add texture.

The spire-like shapes of the darker fir trees are painted wet-on-dry with the point of the No. 5 round sable brush.

4 LEFT BANK
Using directional brush strokes to indicate the slope, Artist 2 lays down mixes of yellow ochre, burnt umber, and ultramarine wet-in-wet.

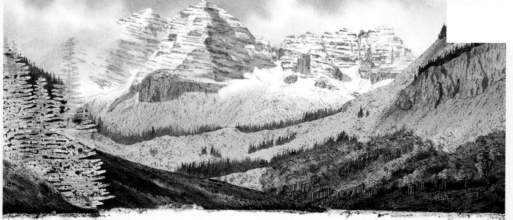

Bands of masking fluid are applied to the trees, and dark washes are laid over the initial layers of paint to suggest vegetation and broken rocks.

5 REFLECTIONS

With the 2-inch (5-cm) flat wash brush, artist 1 floods clean water over the lake. With the No. 10 round sable brush, she builds up layers of paint to create the effect of different colors reflecting off the water's surface.

As the pigment begins to settle in, the brush tip is flicked in short, vertical strokes to mimick the shapes of the trees on the surface of the water.

5 FIR TREES

After removing masking fluid from the trees, Artist 2 blocks in the trees with a mix of aureolin, Winsor green, and burnt sienna. A much denser mix of the wash is then used to paint the shadows beneath each branch.

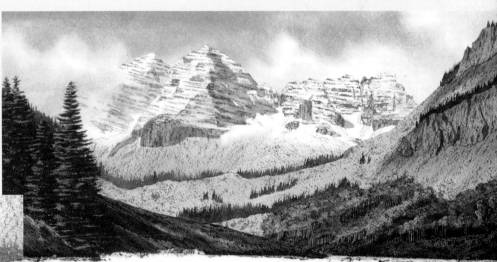

Working wet-on-dry the No. 3 sable brush is used to define the layered branches.

FINISHING TOUCHES

Using light and dark versions of a sap green and Venetian red mix, Artist 1 blocks in the trees on the left, layering the shadows to suggest the structure of the fir. She creates their reflections in the same way. Finally, she lifts some fine lines from the water's surface to suggest ripples.

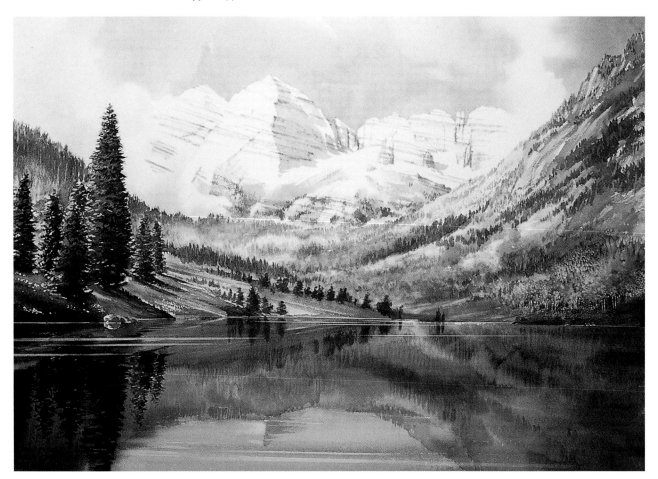

Accentuating the details in the middle distance helps lead the eye into the picture.

Accurate repetition of colors and shapes in the reflections makes the water appear calm and glassy.

COME AUTUMN
(30 X 22 IN/76 X 56 CM, WATERCOLOR ON WATERCOLOR BOARD)

"I started the first version of this painting on a half sheet of paper (15 x 22 in) but felt that it really, really needed to be big. It's one of those classic views, one that draws out the pioneer spirit in us, makes us go and find something that we've never seen before."

Naomi Tydeman

FINISHING TOUCHES
Artist 2 leaves the reflections until last. He dampens the lake with clean water and uses vertical strokes and the 1-inch (2.5-cm) flat brush to flood the land colors over the lake. He then makes a few horizontal strokes with a damp brush and a tissue.

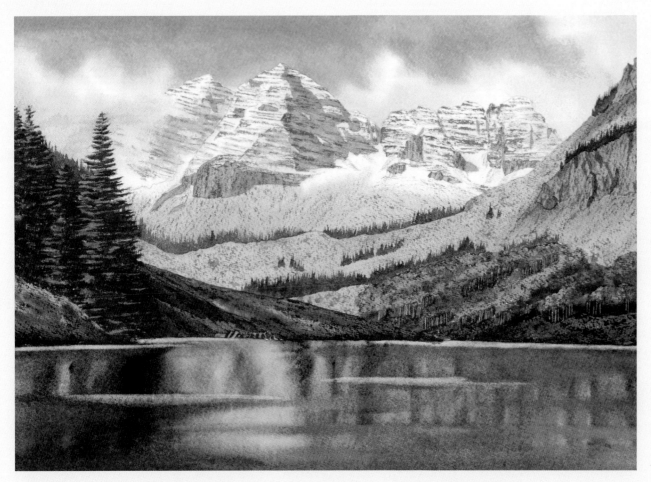

Simplifying the middle distance encourages the eye to move toward the detail in the mountains.

The repetition of the land colors in the reflections gives unity to the composition.

QUIET REFLECTIONS
(15 X 10 IN/38 X 25 CM, WATERCOLOR ON ROUGH WATERCOLOR PAPER)

"I wanted to accurately reproduce this view, without getting bogged down painting tiny trees in minute detail. I think the scene has been simplified just enough—I was pleased with the liquid reflections contrasting the more tightly painted trees above."
Neil Barlow

COMPARING THE WORKS
Artist 1 uses a limited palette of four colors to create a subtle, muted scene, whereas Artist 2 uses nine colors to capture the brilliant fall hues. The artists also convey depth in different ways: Artist 1 keeps the detail in the foreground and middle ground, making the mountains recede, whereas Artist 2 uses warm reds and oranges in the foreground and cool blues in the background to depict atmospheric perspective.

Flower

Flowers are ideal subjects for simple, close-up compositions; their bright colors and delicate curves can fill a painting with richness and interesting shapes. When painting this flower, artists Carol Carter and Karen Vernon both must build up the vibrant colors without overworking them, which can be done by painting wet-in-wet.

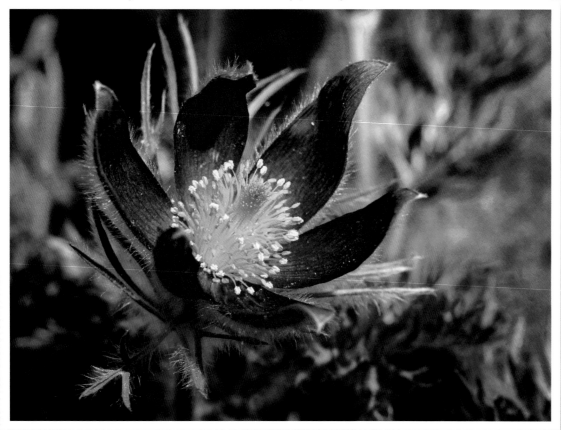

FOCUSING ON COLOR OR DETAIL

When painting a single flower, artists can choose to include more detail for a photo-realistic look or merely suggest details and focus on color for a more abstract result. Both artists use similar wet-in-wet techniques, but they treat the focal point in different ways. Artist 1 gives the bright background the same amount of limited detail as the flower, but the vibrant color of the petals catches the eye, making the flower the focal point. Artist 2 gives the flower a great amount of detail and sets it against a dark background, making the flower advance forward.

■ **Palette**
Burnt sienna
Aureolin
Winsor green
Quinacridone magenta
Dioxazine violet
Cobalt turquoise
Prussian blue

■ **Materials**
Watercolor paper, heavy
Pencil
2-inch (5-cm) flat brush
Various round brushes
Craft knife

■ **Techniques**
Wet-on-dry, page 20
Wet-in-wet, page 20
Blossoms, page 25
Scratching out, page 27
Glazing, page 21

■ **Palette**
Winsor yellow
Cerulean blue
Mars yellow
Permanent rose
Permanent violet reddish
Dioxazine violet
Scarlet lake
New gamboge
Phthalo blue
Quinacridone gold

■ **Materials**
Brush and drawing ink for
 sketch
Watercolor board
1-inch (2.5-cm) flat
 sable brush
No. 6, No. 8, and No. 12
 round sable brushes
Small stiff brush
Metal nib pen

■ **Techniques**
Wet-on-dry, page 20
Wet-in-wet, page 20
Lifting out, page 23
Scratching out, page 27
Glazing, page 21

ARTIST 1:
Carol Carter

Artist 1 begins by making a careful drawing to establish the placement of the flower and the stalk, which are important as they provide a directional line to lead the eye into the picture. She also lightly indicates some areas of tone to act as a guide when she paints the flower.

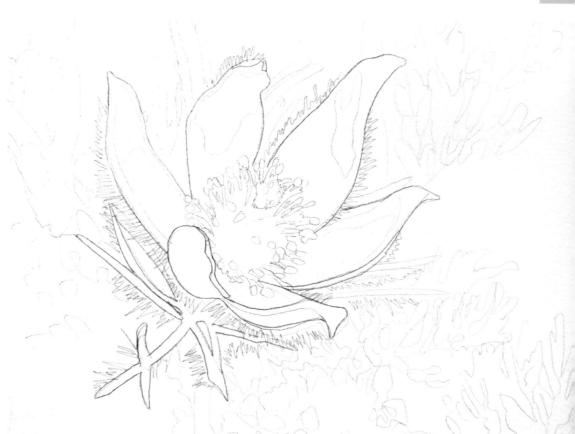

ARTIST 2:
Karen Vernon

For Artist 2, the dramatic dark-light contrasts are as important as the colors, so she makes a tonal sketch using a brush and drawing ink. She then makes a detailed outline drawing on the watercolor board. This careful drawing is very important, as she will be wetting the paper around the pencil lines of the flower.

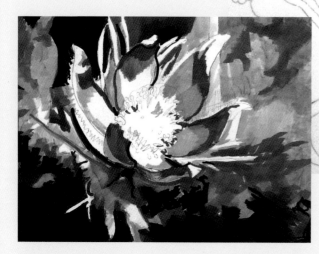

SKETCH
Artist 2 eliminates almost all of the background detail in her outline sketch.

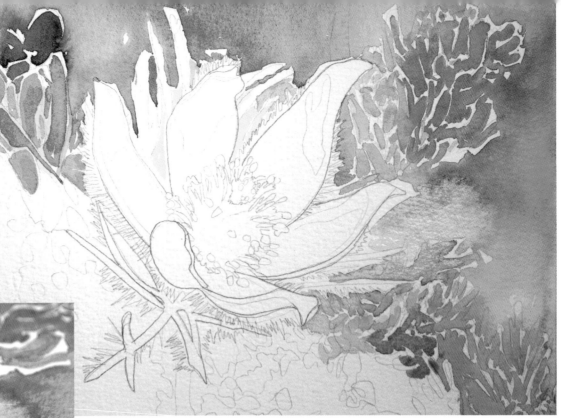

2 FIRST WASH

Leaving some thin, white lines and the flower as dry paper, Artist 1 dampens the rest of the background before flooding a middle-value wash of burnt sienna over it.

Blossoms are created by dropping clean water droplets into a wash that is still damp. The water will push the pigment toward the edges of the puddle, producing shapes resembling florets and blossoms.

2 INITIAL WASH

After wetting the entire background but leaving the flower dry, Artist 2 floods in a Winsor yellow wash. The flower is left white because the red-purple of the petals would be dulled by its complementary color, yellow.

A 1-inch (2.5-cm) flat sable brush is used to lay down the initial yellow wash.

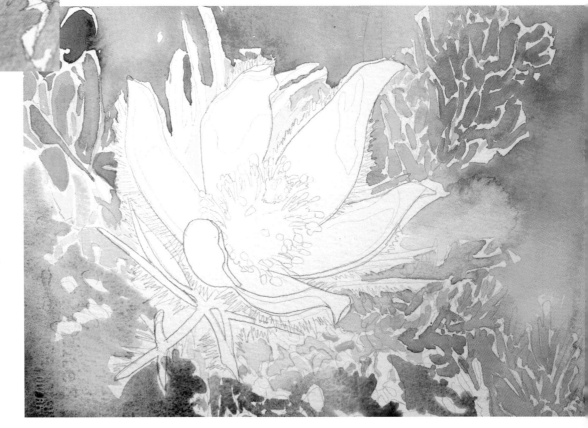

Winsor green is used over the earlier wash while still slightly damp to darken the color. The paint does not flow into the white lines because these were left as dry paper.

3 ADDING COLOR
The white lines in the background become more apparent as Artist 1 drops further color into the still-wet wash. Aureolin is flooded around the outline of the flower to create a halo-like effect, and then Winsor green and touches of magenta are added to the other areas.

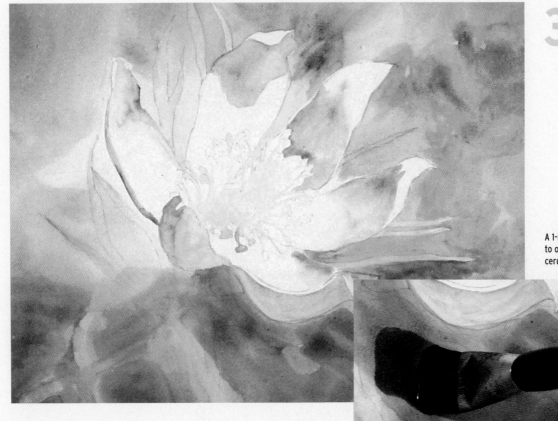

3 COOLER WASHES
Artist 2 floods a cerulean blue wash into the middle and dark values of the flower, as well as over the darker background areas. Mars yellow is glazed over the lighter areas.

A 1-inch (2.5-cm) flat brush is used to overlay the yellow wash with cerulean blue, wet-in-wet.

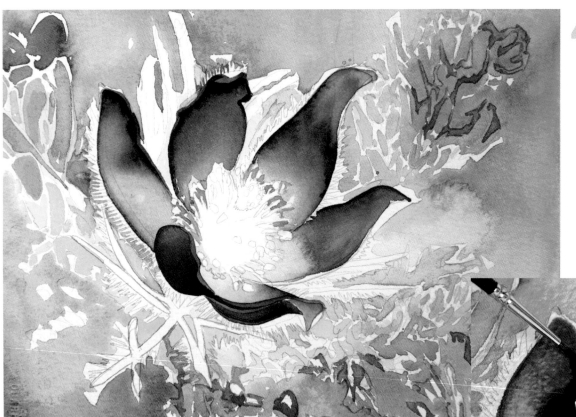

4 **FLOWER**
Wetting each petal with clean water, Artist 1 floats in quinacridone magenta, working from the top so that the pigment becomes diluted as it flows toward the center of the flower.

Dark dioxazine violet is touched in around the edges of the petals while they are still wet.

4 **FLOWER**
Artist 2 drops a mix of permanent rose and permanent violet reddish into the dampened petals. Permanent rose and dioxazine violet are added wet-in-wet for the cooler shadows. Scarlet lake is added to the still-damp petals nearest to the center of the flower.

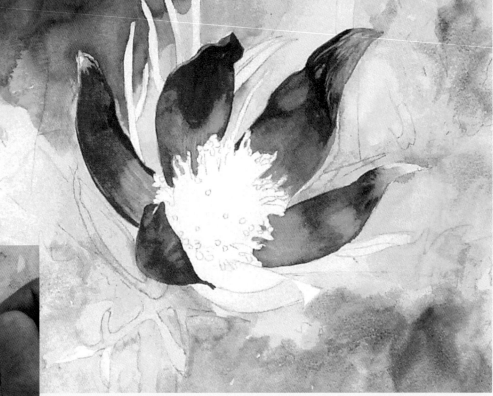

The No. 6 round brush is used to paint the vibrant reds and purples that characterize the petals.

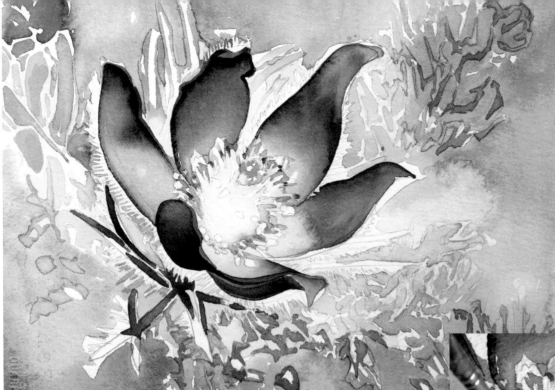

5 FLOWER CENTER

Reserving some white lines for stamens, Artist 1 floods a thin wash of aureolin into dampened paper.

A "light bulb" effect is created by lifting the excess moisture and pigment from the central part of the flower using a damp brush.

The No. 8 sable round brush is used to work in the darker shadows at the base of the flower.

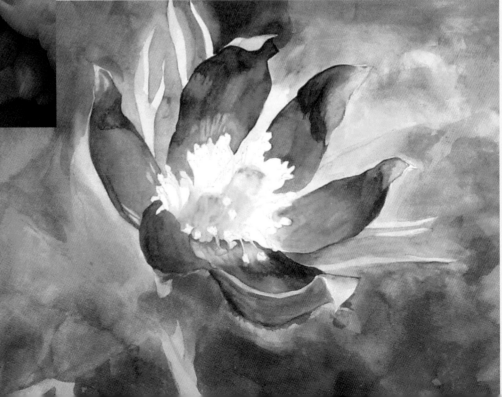

5 ADDING DEPTH

Working wet-in-wet, darker values and shadows are developed under the petals. Then Winsor yellow and cerulean blue are flooded over the bright green areas, and the yellow areas are covered in glazes of scarlet lake and new gamboge.

FINISHING TOUCHES
Painting an intense cobalt turquoise into the saved whites of the background makes the colors vibrate. Artist 1 then uses the fine point of a craft knife to scratch out details in the flower. Then, covering the background with clean water, she floats in Prussian blue from the edges. This glaze of blue turns the warm background tones green and unifies the painting.

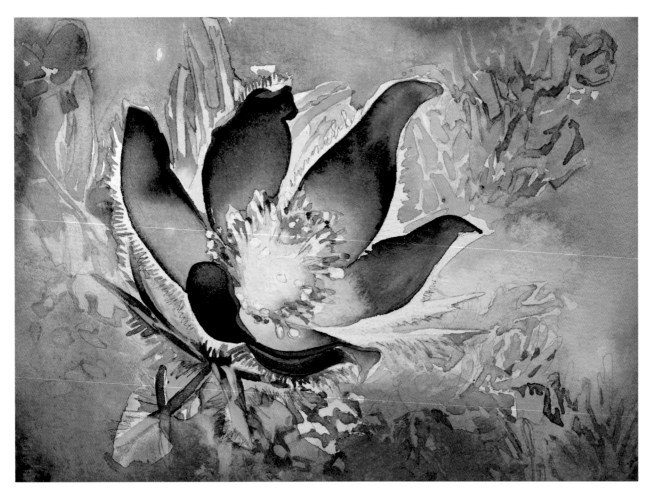

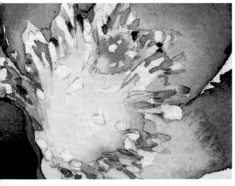

Lifting out color from the center of the flower produces a lovely glowing effect.

The intricate shapes and colored glazes keep the eye dancing around the flower, giving the background equal importance.

OPEN PASSION
(8½ X 11¾ IN/21 X 30 CM, WATERCOLOR ON WATERCOLOR PAPER)

"Like a jewel, the flower's openness is an expression of its affinity for light, an effect enhanced by the yellow halo around the flower that elevates and suspends the blossom. The petals express vitality, and the colors increase the subject's direct visibility, drawing the viewer in."
Carol Carter

FINISHING TOUCHES

Artist 2 glazes a dark mix of permanent violet reddish and phthalo blue diagonally across the background to emphasize the diagonal flow of the composition. The stamens are painted in quinacridone gold and Winsor yellow, with the delicate veins of the petals added in darker shades of reds and purples. The hairs on the sepals and petals were lifted out with a small, damp brush, and some highlights were scratched out with a metal nib.

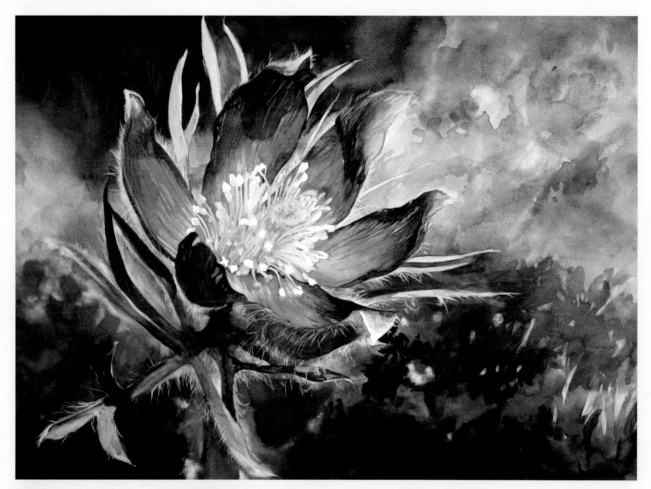

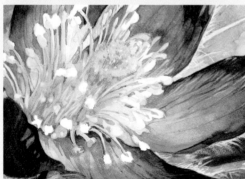

Here, attention has been paid to the way the stamens emerge and grow from the center, giving the flower a sense of realism and individuality.

The dark glazes of the background push the flower forward, drawing the eye toward the fine detail and the subtleties of the petals and stamens.

PURE ESSENCE
(18 X 24 IN/46 X 60 CM, WATERCOLOR ON WATERCOLOR BOARD)

"The simplicity of the subject presented a big challenge, as a single flower creates a static composition that can be a little uninteresting. However, the radiating lines, the flower's texture, and the vibrant color added movement and intriguing detail."
Karen Vernon

COMPARING THE WORKS
Both artists use wet-in-wet methods and brilliant, vibrant color to re-create this subject. However, Artist 1 focuses more on the use of color to bring the flower toward the viewer, setting the purple flower against a complementary yellow background. Artist 2 uses detail in the foreground and the contrast of light and dark (the bright petals against the dark background) to make the flower stand out.

Rapeseed fields

When approaching a simple landscape like this one, an artist must decide whether to make it more complex by focusing on the details—such as the foreground flowers— or accentuate its simplicity by eliminating the details and making it a study in color. Artists Jean Canter and Robert Tilling paint the same scene in very different ways.

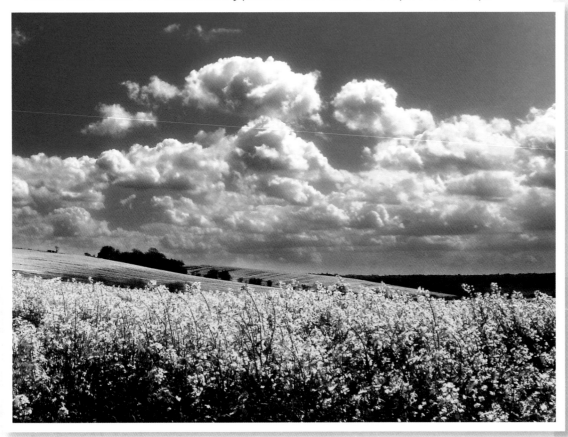

MAKING PERSONAL CHOICES

Artist 1 enjoys describing detail in her paintings, so she chooses to focus on capturing the intricate detail of the flowers in the foreground of this landscape. She does eliminate some of the detail in the clouds, though, as to not distract from the flowers. Artist 2 is attracted to the shapes formed by the field and the use of primary colors, so he chooses to omit all the detail in the foreground so he can focus on what interests him most.

Palette
Light red
Winsor yellow
Aureolin
Antwerp blue
Payne's gray
Viridian
Sepia
Pale raw umber
White gouache

Materials
Watercolor paper
2B pencil
Masking tape
White tissues
Small color shaper
Old bristle brush
Masking fluid
Large sable brush
No. 5 and No. 4 round sable brushes

Techniques
Graduated wash, page 19
Wet-in-wet, page 20
Masking out, page 21
Lifting out, page 23

Palette
Cobalt blue
Cerulean blue
Cadmium yellow
Yellow ochre
Gamboge
Sepia
Viridian
Chinese white

Materials
Watercolor paper
2B pencil
No. 12 large sable mop brush
No. 2 and No. 6 sable brushes
Small towel

Techniques
Wet-in-wet, page 20
Wet-on-dry, page 20
Lifting out (wet), page 22

ARTIST 1:
Jean Canter

Artist 1 produces a fairly detailed and faithful pencil sketch of the original image. The sketch is then photocopied, enlarged, and traced onto the watercolor paper. The artist leaves out the sky and any shading on the watercolor paper.

On the initial sketch, the artist adds shading to get an idea of the pattern of values across the composition.

ARTIST 2:
Robert Tilling

Artist 2 produces a loose, detailed pencil sketch of the subject, paying particular attention to the strong tonal intensities that pin down key elements.

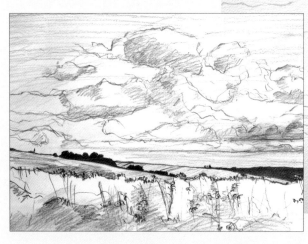

This tonal study is useful later, when applying color.

PREPARATION

Using a 2B pencil, Artist 2 transfers the basic lines of his sketch onto a sheet of watercolor paper. His intention here is not an accurate transposition but artistic freedom with little restriction.

2 BASE WASHES

Artist 1 floods in a graduated wash of light red over the lower half of the sky and paints Winsor yellow over the rapeseed fields. She drops a strong, bright wash of aureolin with touches of light red into the foreground. When this is dry, she dots masking fluid across the single flowers and massed clumps that are part of this foreground.

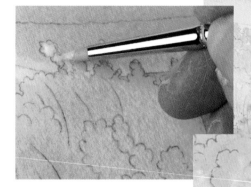

Masking fluid is applied with a small color shaper to mask out detail in the flowers.

An old bristle brush is used to mask out the larger foreground flowers. When the fluid is removed after adding more layers of paint, the flowers will remain pale yellow.

A large sable mop brush is used to lay down the initial wash.

2 BASE WASHES

Artist 2 applies an initial flat wash of diluted cobalt blue and cerulean blue, working it in quickly over the whole painting. While this is still wet, he floods cadmium yellow and a touch of yellow ochre over the lower section of the scene. He then tilts the board to encourage the paint to run down freely for a variegated wash effect.

3 DEFINING THE SKY

Artist 1 dampens the sky and lays on a graduated wash of Antwerp blue using a large sable brush. While this is still wet, she lifts out the clouds with tissues to create soft, diffuse shapes. When dry, she dampens the sky again and adds shadows to the base of the clouds with a mid-tone wash of Payne's gray.

A crumpled tissue is used to press out cloud shapes from the still-wet area.

Cloud shapes are added with a mid-tone wash of Payne's gray.

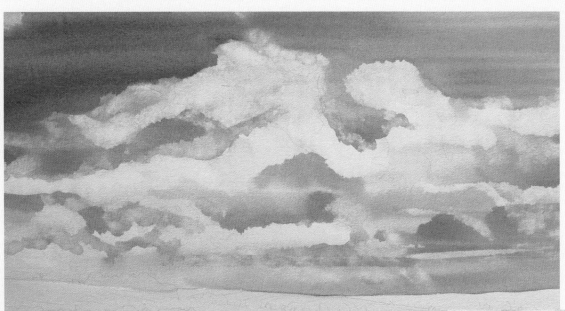

3 SKY AND FIELD

Artist 2 floods the sky using a strong mix of cobalt blue and cerulean blue. He allows this to settle before lifting off the cloud shapes with a small towel. He proceeds to intensify the foreground with a strong wash of cadmium yellow pale and a touch of gamboge.

The towel is used to lift out paint, defining the cloud shapes.

Fine, upward strokes with the tip of a No. 4 round sable brush are used to add small details to the trees in the distance.

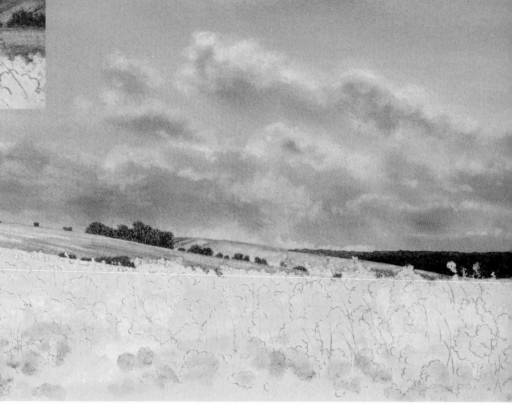

4 DISTANT FIELDS AND TREES
Using a little light red mixed with viridian, Artist 1 washes a deep tone over the distant fields. A darker version of the same two colors is painted into the trees with the tip of a No. 4 round sable brush. The lines and shadows of the distant fields are then defined with a touch of light red.

Painting background detail adds scale to the picture.

4 DISTANCE
Once the paint is dry, Artist 2 mixes sepia and a touch of viridian. Using a No. 2 and a No. 6 sable brush, he paints the distant trees and dark field. A sense of distance begins to emerge in the picture.

5 ADDING FOLIAGE

More viridian is added to the light red, which is then worked into the foliage of the foreground, with touches of sepia to create some leaf shadows. When this is completely dry, Artist 1 removes the masking fluid to reveal the pale shapes of the foreground flowers.

The No. 5 brush is worked in between the masked-out flowers to accentuate the detail in the foliage.

The masking fluid is gently lifted off with a fingertip.

5 DEFINING DISTANCES

Artist 2 sweeps over the field with a large, well-loaded mop brush that carries a large amount of cadmium yellow and gamboge, plus a touch of Chinese white. While the paint is still damp, he brushes a little sepia and viridian into the foreground.

A thin wash of sepia and viridian is used to retouch the fields in the distance.

FINISHING TOUCHES

Artist 1 dots in pale raw umber and aureolin to give more variation to the flowers. She uses upward strokes to paint the stems with sepia. Where a few of the top flowers had lost their sharpness, she dots in white gouache overlaid with aureolin.

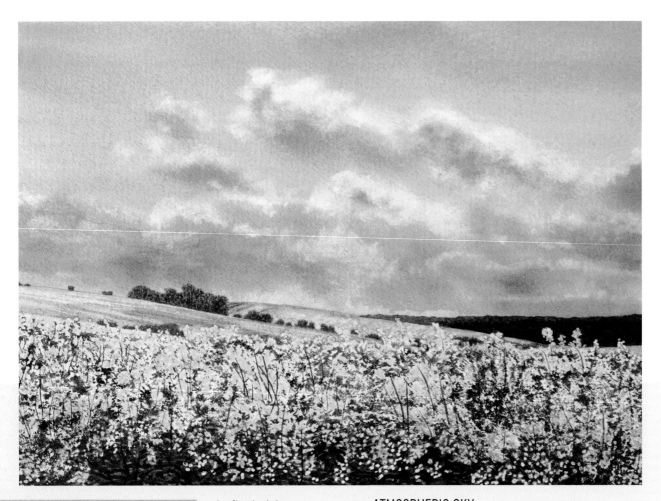

A soft and nebulous effect gives realism to the clouds.

Intricate detail achieved with masking fluid and several layers of paint creates depth and interest in the foreground.

ATMOSPHERIC SKY
(8¹⁄₃ X 12 IN/21 X 30 CM, WATERCOLOR ON WATERCOLOR PAPER)

"On first seeing the photograph, it obviously felt like my sort of landscape with its vast sky and bright lighting conditions. Some experiments were needed, however, in deciding how best to deal with the foreground...but the initial response was one of excitement."

Jean Canter

FINISHING TOUCHES
Artist 2 adds detail to the edges of the field by loading up a fine-tip No. 2 sable brush with a strong mix of cadmium yellow and Chinese white, dotting in some flowers.

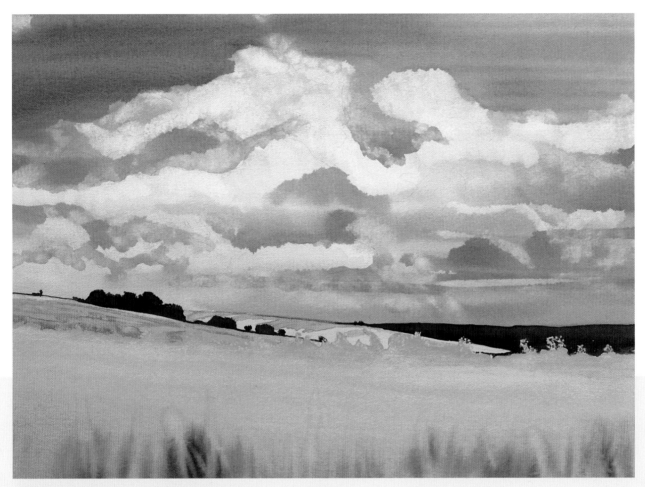

Strong colors and sharp edges create a dramatic cloud pattern in the sky.

The soft, out-of-focus handling of the foreground leads the eye into the picture but does not dominate the scene.

DISTANT FIELDS
(21 X 29 IN/54 X 74 CM, WATERCOLOR ON WATERCOLOR PAPER)

"I was drawn to the large expanse of open sky and wanted to create a sense of openness while making the abstract field shapes the most interesting aspect of the painting. I was not preoccupied with detail, and I allowed chance to play a major role."
Robert Tilling

COMPARING THE WORKS
These contrasting paintings show how a marked difference in intention can result in very different finished works of art. The first is a detailed, visually intricate representation of the subject, whereas the second is an open, almost abstract study in pairing primary colors.

Still-life pears

Still lifes are favorite subjects of artists as they can offer an exciting range of textures, shapes, and tonal contrasts—and they can be interpreted in many different ways! In this lesson, Marjorie Collins focuses on abstract shapes and design, whereas Naomi Tydeman concentrates on building up realistic textures for a more traditional depiction.

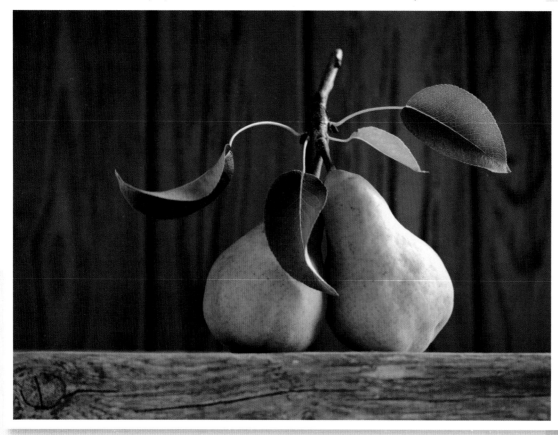

TEXTURE AND FORM
Both artists use different methods to depict the textures of the pears and wooden shelf in this still life. Artist 1 builds up hard-edged areas of tone on the pears to describe their smooth form and uses strong but simple lines to suggest the grainy texture of the wood. Artist 2 uses a more traditional technique of painting the pears wet-in-wet and stippling to add texture; she also builds up the rough texture of the wood with drybrushing.

◼ **Palette**
French ultramarine blue
Mauve
Sepia
Burnt sienna
Winsor blue
Lamp black
Winsor green
Van Dyke brown
Sap green
Aureolin
Hunter's green

◼ **Materials**
Watercolor paper, heavy, cold-pressed
Pencil
No. 12 round sable brush
No. 6 and No. 8 round synthetic brushes

◼ **Techniques**
Glazing, page 21
Wet-on-dry, page 20

◼ **Palette**
Winsor blue
Venetian red
Winsor lemon
Manganese blue

◼ **Materials**
Watercolor board
Pencil
Masking fluid
Dip pen
No. 5 and No. 10 round sable brushes

◼ **Techniques**
Wet-on-dry, page 20
Masking out, page 21
Wet-in-wet, page 20
Lifting out, page 23
Drybrush, page 23

1 **ARTIST 1:
Marjorie
Collins**

Artist 1's initial
drawing on the
watercolor paper
pins down the
shapes of the
objects in the
composition,
outlining their
forms as defined
by patterns of
light and shadow.
Some details will
later be simplified.

1 **ARTIST 2:
Naomi Tydeman**

In her simple outline sketch of the pears,
Artist 2 decides to shift the position of the
background wood paneling so the groove
in the grain does not run directly behind
the twig.

The sketch gives the artist ideas for subtle changes to the composition.

Artist 2 prepares two separate washes by mixing Venetian red and
Winsor blue: one warm with more red and the other cool with more blue.
Alternating and blending these two washes in turn, she lays down two
light layers across the shelf with the side of the No. 10 round sable brush.
The cracks and grain of the wood are added with the dip pen, and several
more light layers are then drybrushed over the top.

French ultramarine blue and mauve washes of varying intensities are used to build up simplified tonal patterns in layers.

2 SHADOWS

Artist 1 begins with a tonal underpainting. First she lays a wash of ultramarine and mauve over the whole painting except for the white highlights. Then she uses a stronger version of the same mixture to layer on the darker tones, working wet-on-dry with the No. 12 sable brush and the No. 6 synthetic brush.

2 BACKGROUND

Artist 2 uses masking fluid and the dip pen to outline the shapes of the pears and leaves. Then she paints a layer of the warm wash over the background paneling. When this is dry, she uses the side of the No. 5 round sable brush to overlay the cool wash using drybrush strokes.

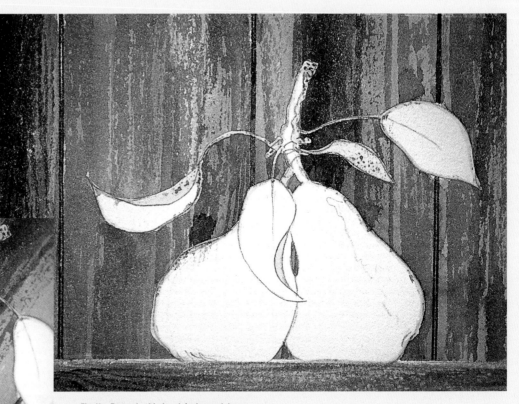

The No. 5 round sable brush is dragged down the length of the wood paneling until she comes to the edges of the pears, where masking fluid has been applied.

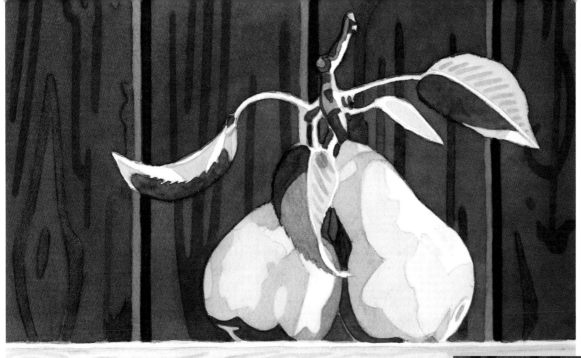

3 BACKGROUND

Artist 1 paints the grain of the wood with burnt sienna, allows it to dry, and then paints a mix of Winsor blue and lamp black around the light brown areas. When dry, Winsor green is flooded in, again reserving the grain pattern. A unifying blue-black wash is then laid over the whole area, except for the vertical lines.

The tip of a No. 12 round sable brush is used to glaze the blue-black wash around the areas painted with burnt sienna.

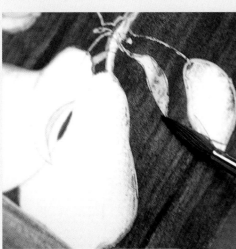

The No. 5 round sable brush is used to apply a final glaze of manganese blue, which unifies the background.

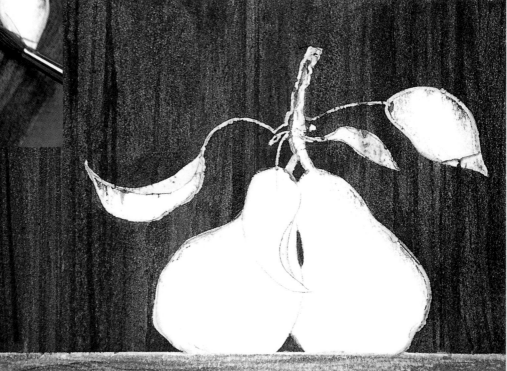

3 ADDING TEXTURE

Artist 2 uses a fairly thick mix of manganese blue toned down with a hint of Venetian red to add layer upon layer of drybrushed paint. She alternates it with the warm wash until satisfied with the resulting texture.

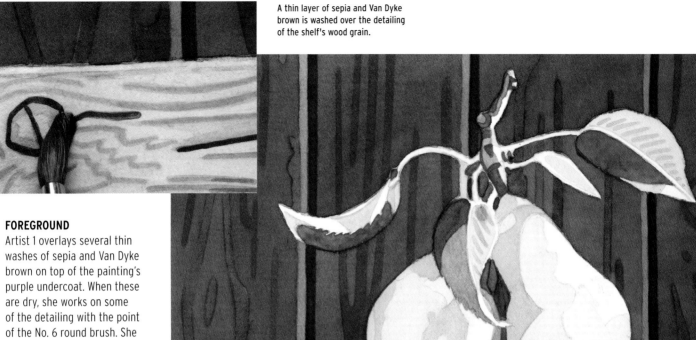

A thin layer of sepia and Van Dyke brown is washed over the detailing of the shelf's wood grain.

4 FOREGROUND

Artist 1 overlays several thin washes of sepia and Van Dyke brown on top of the painting's purple undercoat. When these are dry, she works on some of the detailing with the point of the No. 6 round brush. She drops a broad wash over the entire shelf with the No. 12 round brush, avoiding the light edges at the top.

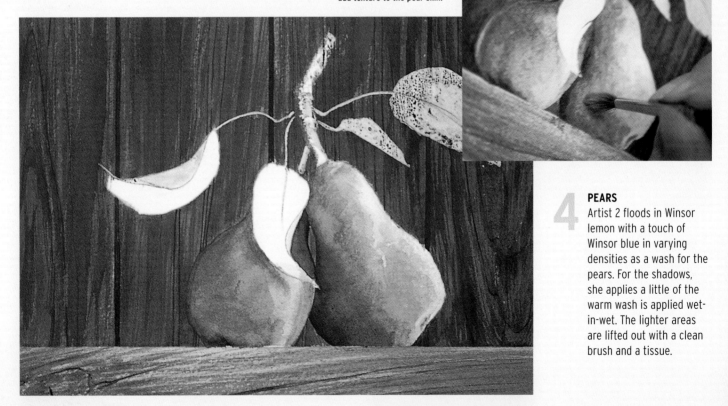

Using a short-haired brush, some stippling is applied to add texture to the pear skin.

4 PEARS

Artist 2 floods in Winsor lemon with a touch of Winsor blue in varying densities as a wash for the pears. For the shadows, she applies a little of the warm wash is applied wet-in-wet. The lighter areas are lifted out with a clean brush and a tissue.

5 PEARS

Avoiding the white sections reserved for highlights, Artist 1 applies a light wash of sap green with aureolin to the underpainting of the pears. Working wet-on-dry, she gradually builds up layers in successively darker versions of this mix until the pears appear green.

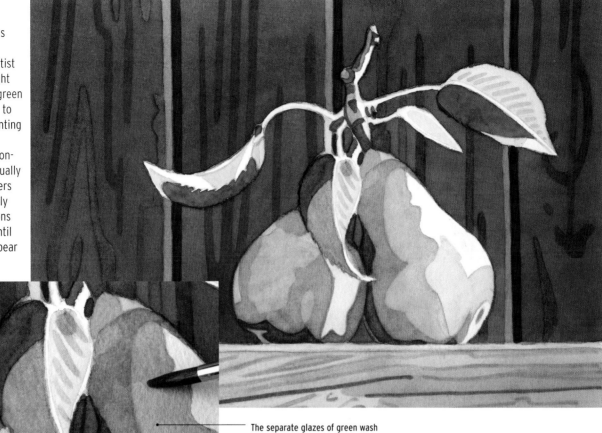

The separate glazes of green wash are clearly visible as the artist builds up the form of the pears.

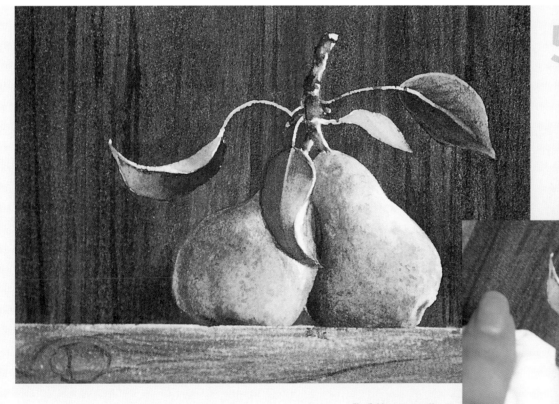

5 LEAVES

Artist 2 paints the leaves with a slightly richer mix of Winsor lemon and blue, and she uses a stronger version of the cool wash wet-in-wet to define the leaf shadows.

The lighter areas on the leaf are lifted out with clean water and a tissue.

FINISHING TOUCHES
Artist 1 paints a dark wash of Hunter's green over the deepest purple shadows of the leaves, and
then paints the lighter areas with a very thin glaze of the same color. She refines the branch by
applying a strong wash of burnt sienna and some details in sepia. To make the pears stand out,
she subdues the background with a glaze of the blue-black wash used earlier. Finally, Artist 1
brushes a thin lamp black wash over the shelf to balance the tones.

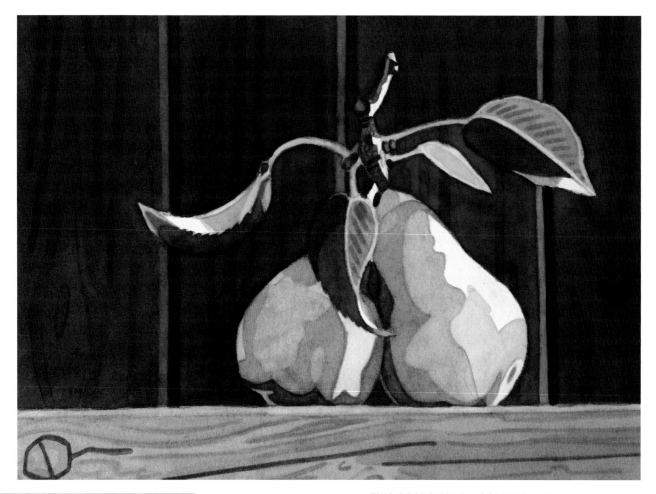

Flat planes of color with
strong lines accentuate
the design of the image.

Reducing the contours of
the pears into a series
of flat planes in different
tones creates a lively
pattern and describes
the forms.

TWO PEARS ON A WOODEN SHELF (9½ X 12 IN/24 X 30 CM, WATERCOLOR ON HEAVY, COLD-PRESSED WATERCOLOR PAPER)

"The basic composition of this subject was very
striking and, wanting to make sure the pears
stood out, in the end I simplified and subdued the
background and foreground details so the pears
would jump out."
Marjorie Collins

FINISHING TOUCHES

Artist 2 uses a stronger mix of the warm wash to paint a subtle shadow behind the pear on the left. She then lightens sections of the wooden paneling to the right of the pears by lifting out paint with a damp tissue. Sensing that the shelf needs to come forward a little, she adds extra texture with the dip pen and some drybrush strokes of the warm wash.

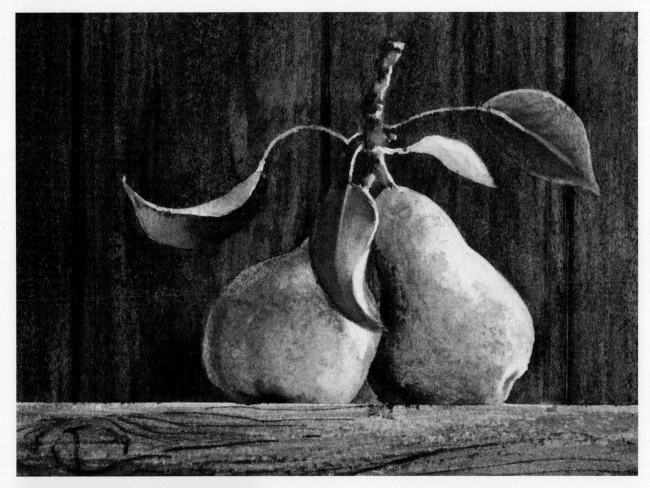

The texture of the wood is seen as important in this painting, and is achieved with drybrush strokes.

The realistic approach gives a three-dimensional look to the pears.

STUDY OF TWO PEARS (4³/₄ X 6¹/₂ IN/12 X 17 CM, WATERCOLOR ON WATERCOLOR BOARD)

"I made this painting very small, feeling that a tiny painting would feel more intimate and make the viewer come closer to see the detail. I thought the original photograph quite beautiful and got totally absorbed in the textures."

Naomi Tydeman

COMPARING THE WORKS

Both artists have stuck to the composition of the reference image. However, Artist 1 has created an almost collage-like impression through her use of hard edges, strong shapes, and dramatic tonal contrasts, whereas Artist 2's painting is more traditional in feel and concentrates on developing realistic textures.

Sunset

This seaside sunset is a lovely subject, but the clouds are complicated and compete for attention with the colors of the sunset. The foreground also is complex and distracting. In this lesson, artists Naomi Tydeman and Robert Tilling simplify different elements in the reference to improve their compositions.

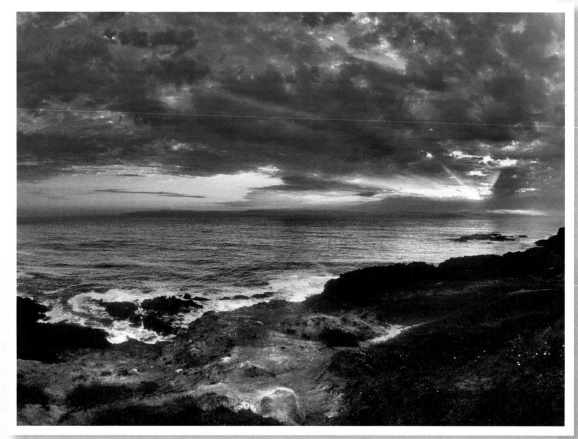

SIMPLIFYING A SCENE

To create a more pleasing composition, both artists eliminate certain details from the photo reference. Artist 1 simplifies the clouds, using wet-in-wet techniques to create soft-edged areas of color rather than detailing the individual cloud shapes. She decides to keep some detail in the foreground rocks but uses the same colors from the sky to unify the painting. Artist 2 simplifies the clouds even further, opting for a band of blue color with just a hint of clouds. He removes almost all detail from the water and foreground rocks, instead concentrating on their shapes and colors.

■ **Palette**
Winsor blue
Venetian red
Dioxazine violet
Permanent rose
Cadmium yellow

■ **Materials**
Watercolor board
2B pencil
Masking fluid
Dip pen
Salt
2-inch (5-cm) flat brush
No. 5 and No. 10 round sable
 brushes

■ **Techniques**
Masking out, page 21
Graduated wash, page 19
Wet-in-wet, page 20
Wet-on-dry, page 20
Using salt, page 26
Scumbling, page 24

■ **Palette**
Cerulean blue
Cobalt blue
Mauve
Turquoise
Cadmium yellow
Naples yellow
Ultramarine
Alizarin crimson
Chinese white

■ **Materials**
Watercolor paper
2B pencil
Large soft pencil
Towel
No. 12 sable mop brush
No. 3 and No. 6 round sable
 brushes

■ **Techniques**
Wet-in-wet, page 20
Wet-on-dry, page 20
Lifting out (wet), page 22

ARTIST 1:
Naomi Tydeman

Artist 1 makes a preliminary sketch using light pencil lines for the horizon and distant hills and darker lines for the foreground. The sky has not been sketched in.

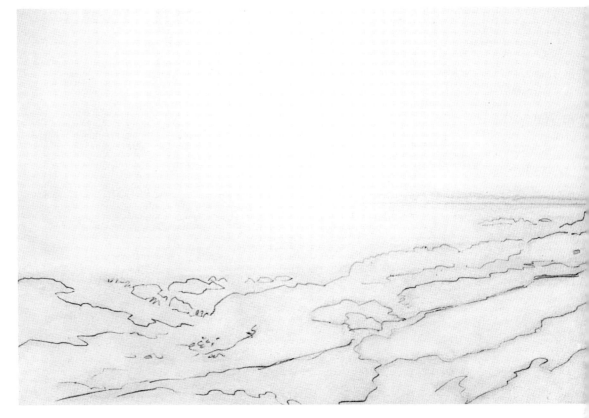

No pencil marks are made in the sky to allow the paint to flow freely.

ARTIST 2:
Robert Tilling

This artist rarely works from photographs, so he treats his preliminary sketch as he would if working from life, using it to plan the composition. He has drawn the cloud formations, but will simplify them in the painting.

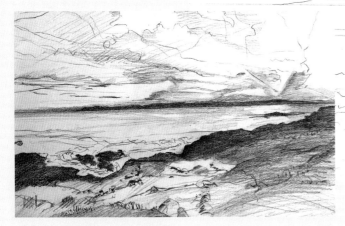

The sketch captures the key compositional features and establishes the main elements.

FIRST STAGE
Artist 2 makes only faint pencil lines on the working surface, as he finds that a detailed drawing restricts his freedom to interpret the subject.

2 FIRST STAGES

Artist 1 masks out the areas of surf breaking over the rocks and, once dry, drags her finger over them to break up the edges. After preparing a wash of Winsor blue, Venetian red, and dioxazine violet, she then paints the distant coastline with several thin layers.

The No. 5 round sable brush is used to layer the distant coastline with thin washes.

2 INITIAL WASHES

Artist 2 coats the paper with a wash of diluted cerulean blue and a hint of cobalt blue. While this is still wet, he adds a diluted wash of mauve to the horizon line, followed by a very faint wash of turquoise to the sea. He tilts the board while the paint is still wet to help the paint flow in the direction he wants.

A large sable mop brush is loaded to lay down the initial washes.

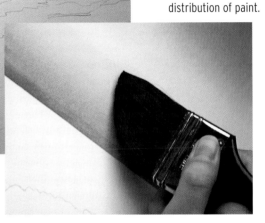

3 **SKY WASH**
Artist 1 prepares several washes: permanent rose, cadmium yellow, and a blue made from Winsor blue with a touch of Venetian red to tone it down. She wets the whole area with the 2-inch (5-cm) flat brush before applying color, occasionally tilting the board to one side to allow for an even distribution of paint.

The sky is laid down using the 2-inch (5-cm) flat brush.

A large sable mop brush is used to flood the paint.

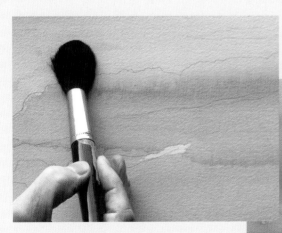

3 **WARMING THE SKY**
Artist 2 adds more of the blue wash to the top of the sky, and then brushes over the lower section of the sky with a diluted wash of cadmium yellow tinted with Naples yellow. He then applies a touch of mauve to the distant horizon area and the foreground and leaves this to dry.

The No. 10 round sable brush is used to create clouds.

4 CLOUD FORMATIONS

With the 2-inch (5-cm) flat brush, Artist 1 wets all the paper above the horizon with clean water, working quickly so as not to disturb the pigment below. Then, with a darker version of the blue/purple wash used for the distant hills, she paints the layers of clouds.

A large sable mop brush is used to add color and texture to the darker areas of the foreground.

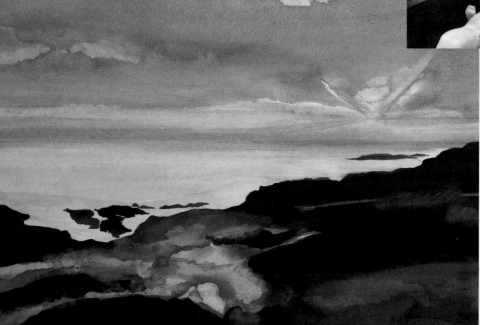

4 ADDING IN THE DARKER AREAS

Artist 2 prepares a strong wash of cobalt blue and cerulean with a touch of ultramarine. Using the large sable mop brush, he floods the sky with this wash. Once this is almost dry, he presses a towel into the paper to lift out the clouds. He then blocks in the rocks using the No. 6 sable brush loaded with phthalo blue and touches of mauve and alizarin crimson. The same color is washed over the foreground and the towel is used to lift out the lighter areas of the foreground.

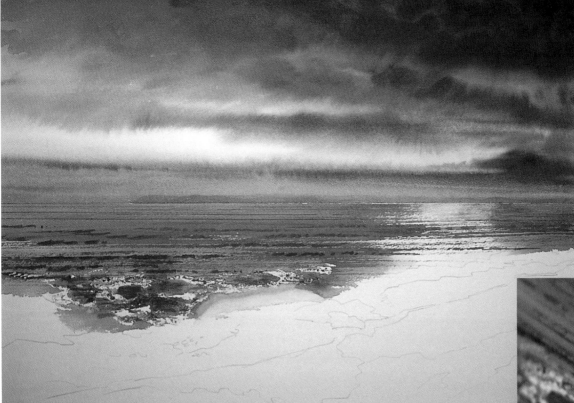

5 SEA

Using the same washes as before, Artist 1 paints the sea, which reflects the sky color. When this is dry, she paints in streaks and shadows with a couple of drybrush strokes and adds some thin lines in the distance.

The distant shadows of the sea are drawn using the ruler and dip pen.

5 DISTANT DETAILS

For the distant coast-line, Artist 2 brushes on a line of cobalt blue and ultramarine across the horizon and allows it to dry. He then washes over it with a wider band of color to create the hazy quality of the lower sky. Some diluted alizarin and cadmium yellow is flooded in for variation before the paint dries.

The rays of the sun are created using a tiny amount of cadmium yellow and Naples yellow on the No. 6 round sable brush.

FINISHING TOUCHES
Mixing all the colors used in the sky, Artist 1 paints the rocks and the foreground, working wet-in-wet and lifting some colors and strengthening others. To create the textures of the rocks, grasses, and pebbles, she sprinkles salt into damp patches and scumbles over dry areas. She then removes the masking fluid, and paints the breaking surf with a diluted version of the sky wash. Finally, with the bristle brush and clean water, some of the yellow is lifted to create a soft, gentle glow for the sun.

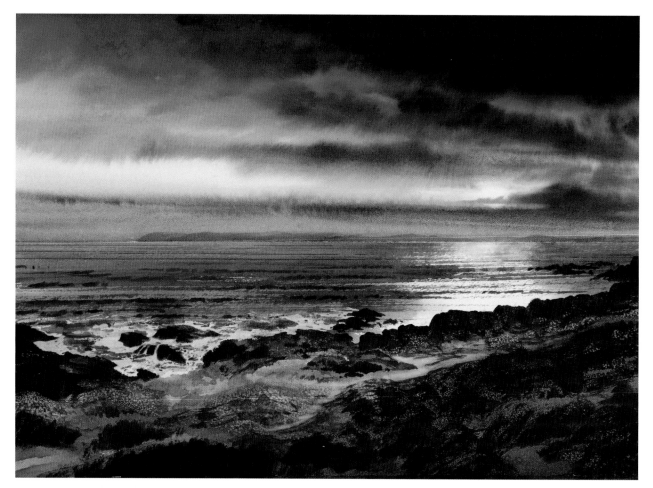

Masking fluid, several washes, and drybrush strokes are used to create texture in the sea.

Dark layers floated over a re-wetted sky give the clouds a soft edge.

REMAINS OF THE DAY
(15 X 22 IN/38 X 56 CM, WATERCOLOR ON WATERCOLOR BOARD)

"When I first saw the photograph, I groaned inwardly. The foreground is unclear, verging on ugly, the clouds are complicated, there are too many colors and the horizon is slap bang in the middle. I kept to a limited palette and I was pleasantly surprised in the end."
Naomi Tydeman

FINISHING TOUCHES
With a mix of cadmium yellow, Naples yellow, and Chinese white, Artist 2 works into the sun and its reflection with a No. 3 sable brush. The final horizon line is painted with cobalt blue and cerulean blue.

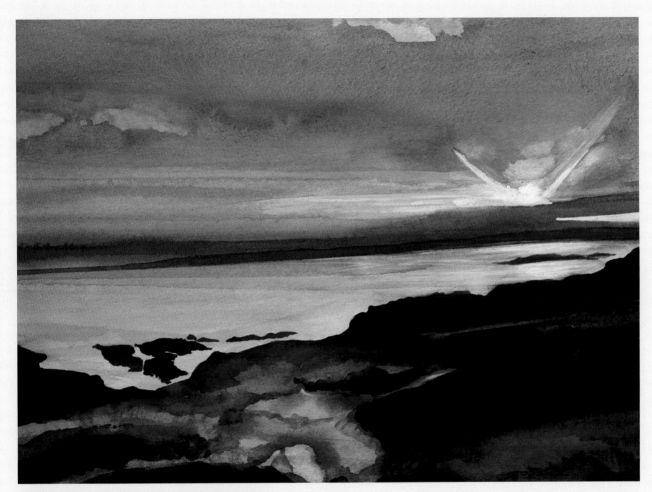

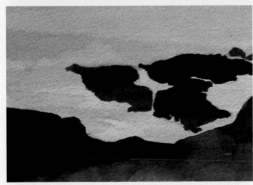

The sea is left as a simple color with strong, dark shapes defining the edge.

Color is lifted from the sky in straight lines and then touched with yellow, creating the rays of the setting sun.

LAST LIGHT
(21 X 29 IN/54 X 74 CM, WATERCOLOR ON WATERCOLOR PAPER)

"I was immediately attracted by the strong colors and abstract qualities of this magical seascape. I wanted to translate the fascinating foreground shapes and powerful color rather than concern myself with detail. I did not copy the photograph but interpreted it with a generous amount of artistic freedom, allowing for a great deal of chance during my wet-in-wet technique."
Robert Tilling

COMPARING THE WORKS
Two contrasting approaches have resulted once again in very different paintings. The first is a romantic interpretation; the second is free and imaginative, with a vast sense of space.

Watermill reflection

Water always makes an interesting subject, even when it isn't the focal point of a painting. There are as many different ways to render water—and the varied colors and shapes it reflects—as there are forms it takes. Here artists Milind Mulick and Steven Bragg use different approaches in rendering the reflections, resulting in drastically different paintings.

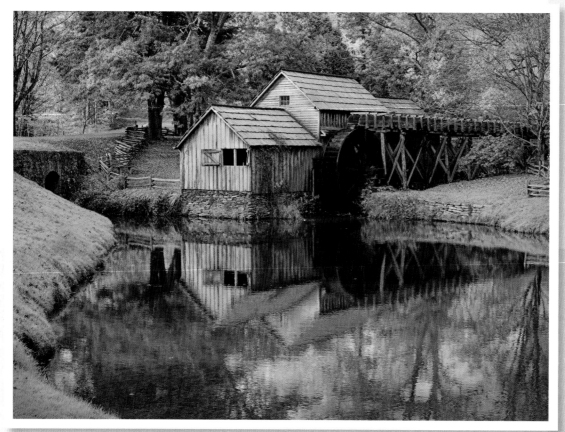

PAINTING REFLECTIONS

The water in the photo reference is relatively still near the mill and slightly stirring in the foreground, which makes the reflection of the mill almost a mirror image and the reflections of the trees and foliage blurry and elongated. Artist 1 is fairly faithful to the photo reference, though she simplifies the reflection of the mill and trees, blurring the edges to create the illusion of slight movement. Artist 2 takes a completely different approach, rendering almost as much detail in the reflections as in the actual objects themselves for an abstract look.

■ Palette
Chrome yellow
Viridian green
Sap green
Orange
Vermilion
Lemon yellow
Crimson
Cobalt blue

■ Materials
Watercolor paper
4B pencil
1-inch (2.5-cm) flat brush
½ inch (1.3-cm) flat brush
No. 6 round sable brush
Rigger brush

■ Techniques
Wet-on-dry, page 20
Spattering, page 25
Wet-in-wet, page 20

■ Palette
Cadmium yellow light
Yellow ochre
Raw sienna
Burnt sienna
Phthalo green
Cadmium red light
Quinacridone violet
Ultramarine blue
Burnt umber

■ Materials
Watercolor paper, cold-
 pressed
Graphite stick
No. 1, No. 2, No. 3, and No. 6
 round brushes

■ Techniques
Wet-in-wet, page 20

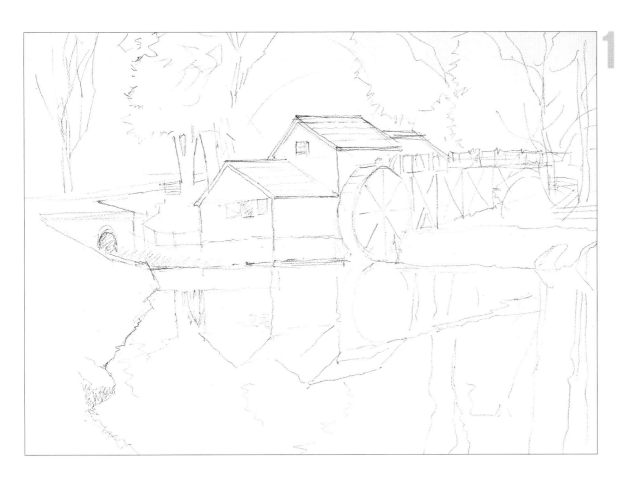

ARTIST 1:
Milind Mulick

Artist 1 pencils in the cluster of buildings, working from the center toward the edges of the watercolor paper and linking the shapes of trees, reflections, and the left-hand bank to the millhouse.

ARTIST 2:
Steven Bragg

For Artist 2, tone plays the most important part in achieving a balanced picture, so he begins with a tonal sketch, using firm strokes of a graphite stick.

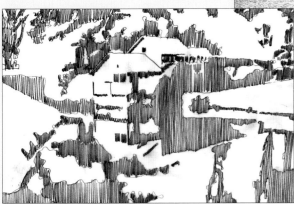

The tonal sketch establishes lights and darks.

Artist 2 makes a very detailed preliminary drawing that maps out patterns of light and color and establishes the position of the main elements.

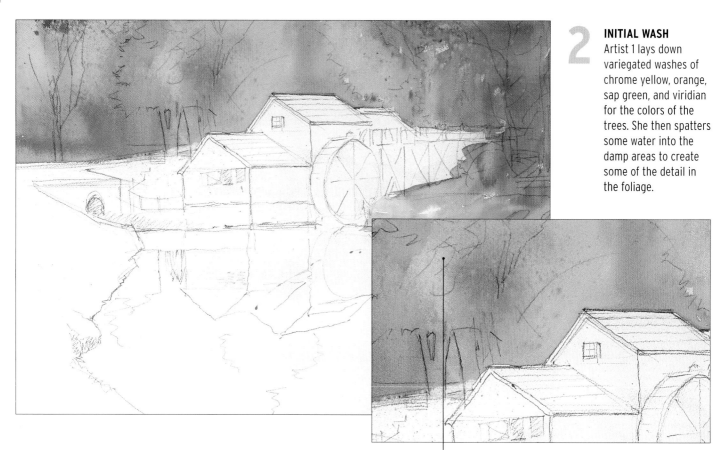

2 **INITIAL WASH**
Artist 1 lays down variegated washes of chrome yellow, orange, sap green, and viridian for the colors of the trees. She then spatters some water into the damp areas to create some of the detail in the foliage.

Loose, flowing washes create color variations within the foliage.

2 **BRIGHTS**
Artist 2 uses the No. 3 round brush to paint the brightest tones across the picture—cadmium yellow light with touches of burnt sienna and cadmium red light. He then mixes in phthalo green and cadmium yellow for the greens, and he applies ultramarine in various densities for the blues.

The pigments are allowed to bleed into each other wet-in-wet.

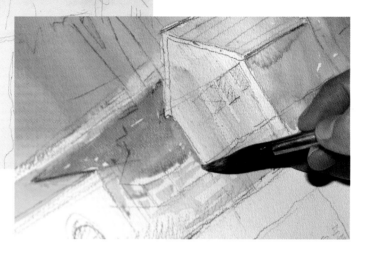

3 BUILDINGS

The building's shadows are applied using a light mix of cobalt blue and crimson with some orange flooded in to suggest areas of reflected light. Artist 1 then works the left riverbank with a mix of viridian and lemon yellow, adding vermilion, an important color accent, under the trees.

The background behind the buildings is worked using the No. 6 round brush, leaving out tiny white sections for the fencing.

Pinks and oranges are introduced to the picture by using cadmium red, yellow ochre, raw sienna, cadmium yellow light, and quinacridone violet.

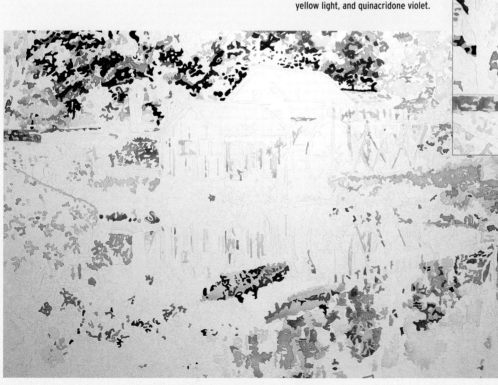

3 MID TONES

Artist 2 starts to add the mid tones with various grays and darks from a mixture of ultramarine and burnt sienna.

Worked wet-in-wet with the ½-inch (1.3-cm) flat brush, the colors of the foliage are allowed to blend and flow around the dry reflections of the buildings.

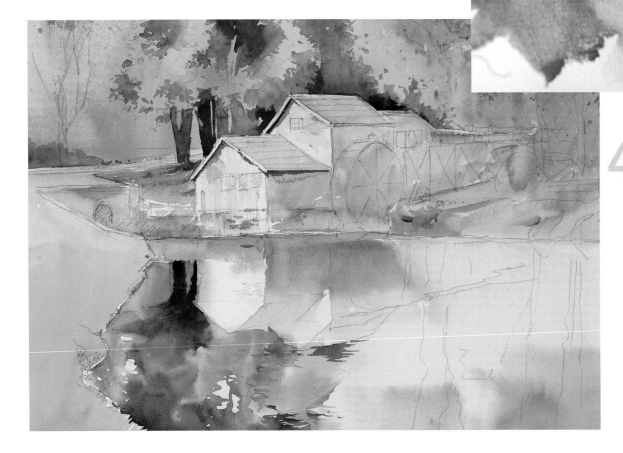

REFLECTIONS

First, Artist 1 adds depth and shadows to the trees behind the buildings. Then she carefully wets the reflections of the shadow sides of the building before flooding in a mix of cobalt blue and crimson. When this is dry, she wets the area reflecting the trees and blends in the colors used previously.

NEUTRALS

Artist 2 thinks of the lights and darks as the star players and the neutrals as his supporting cast. The neutrals perform a vital role, as they anchor the bright colors. Various amounts of burnt umber, burnt sienna, and raw sienna form the browns.

The greens are toned down with varying strengths of the ultramarine and burnt sienna mix.

5 DETAILS

Taking care not to overdo the detailing on the buildings, Artist 1 adds deeper shadows to the waterwheel, being careful to reserve the spokes and struts of the conduit as the lighter color. Shadows are also added to the bridge and the riverbank, which helps to ground them.

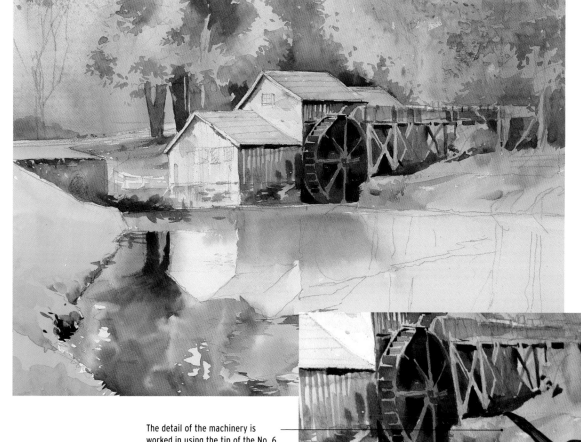

The detail of the machinery is worked in using the tip of the No. 6 round brush.

5 DARKS

In nature, a reflection will always appear slightly darker than the actual object because some light penetrates the water's surface and does not bounce back. Aware of this, Artist 2 paints his most intense darks into the water.

The blues are a combination of pure ultramarine and the ultramarine and burnt sienna mix.

FINISHING TOUCHES

Artist 1 wets the right side of the river with clean water before painting the remaining reflections wet-in-wet, adding more depth under the waterwheel. To complete the painting, she adds sharp detail to the windows and tree trunks, and she paints some twigs using the rigger brush.

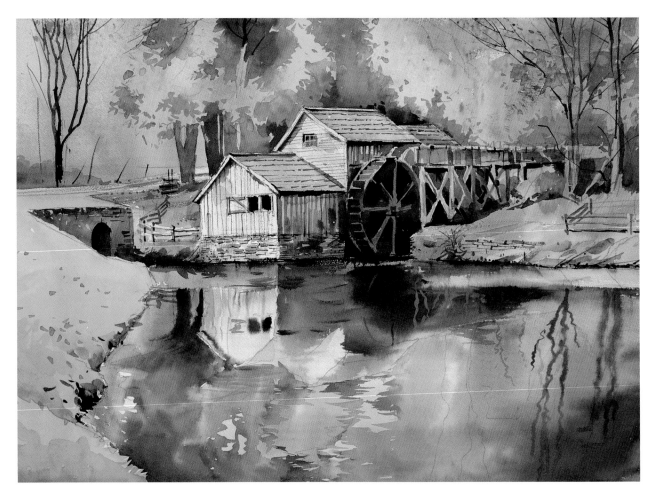

The soft edges of the reflections give the effect of slight movement in the water.

Lack of detail in the trees focuses the eye on the main element—the mill.

FALL COLORS—REFLECTION

(15 X 19 IN/38 X 48 CM, WATERCOLOR ON WATERCOLOR PAPER)

"Rather than copying a photograph I think I have managed to create a play of colors and shapes. A photograph records sharp detail from corner to corner, whereas our experience of reality is an inability to focus on more than one thing at a time. I have therefore concentrated the sharpest lines and contrasts toward the center."

Milind Mulick

FINISHING TOUCHES
Artist 2 uses a dense mix of ultramarine and burnt sienna to proceed with the absolute darks through the shadows and the reflection of the millhouse. Concerned about its tonal values, he tackles the left bank last of all, adding several gray washes with the No. 6 round brush to subdue it.

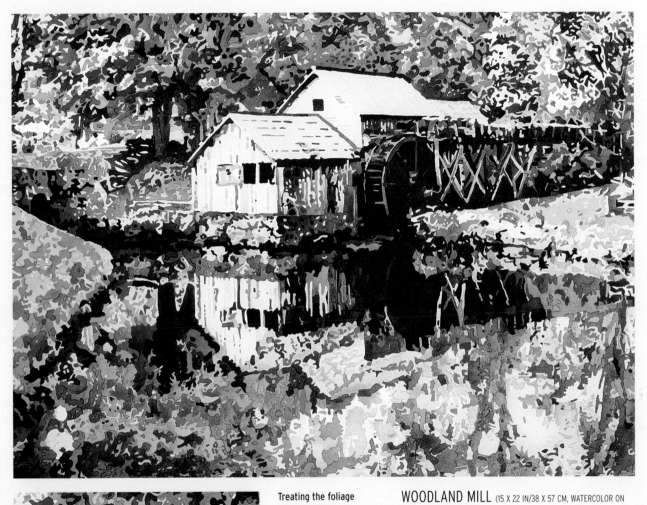

Treating the foliage with exactly the same amount of detail as the buildings gives the entire image an overall rhythm.

The dark tone of the reflection helps to define the light shape of the reflected mill.

WOODLAND MILL (15 X 22 IN/38 X 57 CM, WATERCOLOR ON COLD-PRESSED WATERCOLOR PAPER)

"For this painting I chose tube-based watercolor. The technique I used took considerable time, so it was important to use a medium that could be regenerated successfully. The detailed reflection in the painting was a long, slow process!"
Steven Bragg

COMPARING THE WORKS
This chromatically vibrant and challenging scene has prompted two completely different approaches. The first painting results in a work that is loose, evocative, and unafraid to exploit the translucent, flowing qualities of watercolor. The second painting is a complex pattern that reduces the forms to an incredible network of darks, lights, and colors.

Mediterranean wall

The direct lighting of this warm European scene makes it look flat and two-dimensional, so artists Milind Mulick and Adrie Hello must create visual interest in their paintings. This can be done by focusing on texture, guiding the eye through visual paths, and using color to form areas of interest.

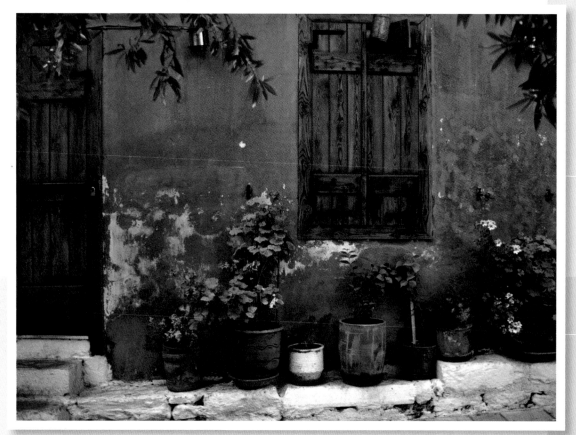

CREATING INTEREST WITH COLOR

When painting this scene, both artists changed the colors of the original photograph to create areas of interest. Artist 1 significantly lightens all the tones in the scene, making the plants stand out more and the rough texture of the peeling wall more apparent with areas of white peeking through. Artist 2 changes the color scheme entirely, using complementary colors yellow and purple. The multicolored textures on the yellow wall add visual interest, and the purple shadows around the plants and on the door lead the eye around the painting.

Palette
Burnt sienna
Chrome yellow
Vermilion
Sap green
Viridian
Crimson
Cobalt blue

Materials
Watercolor paper, cold-pressed
4B pencil
1-inch (2.5-cm) flat brush
½-inch (1.3-cm) flat brush
No. 6 and No. 10 round brushes
Rigger brush
Tissue

Techniques
Drybrush, page 23
Wet-in-wet, page 20
Wet-on-dry, page 20
Lifting out, page 23
Spraying water, page 26

Palette
Payne's gray
Gold ochre
Brown madder
Ultramarine
Alizarin crimson
Indian yellow
Cadmium yellow pale
Raw umber
Cobalt blue
Cadmium red
Burnt sienna

Tools and materials
Watercolor paper, cold-pressed
Masking fluid
Candle
Toothbrush
Spray bottle
Rigger brush
No. 4, No. 10, and No. 16 round sable brushes
No. 9 mop brush

Techniques
Masking out, page 21
Wax resist, page 24
Spraying water, page 26
Spattering, page 25
Wet-in-wet, page 20

1 ARTIST 1:
Milind Mulick

Artist 1 begins with a quick line sketch and an initial color wash to establish the relationship of color and tone. She understands that strength of color is vital to the overall picture and tries to establish a visual flow.

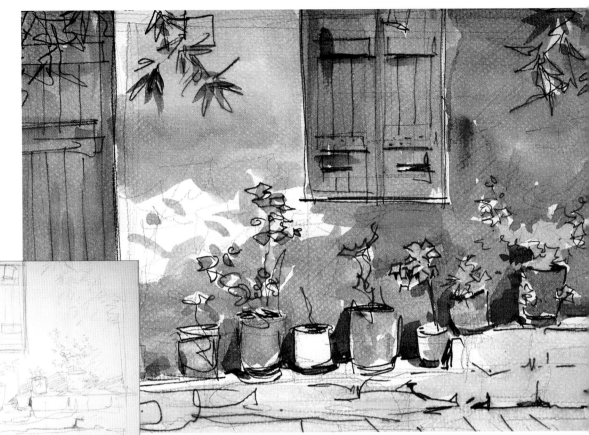

LINE SKETCH
This quick sketch is used to establish compositional elements.

1 ARTIST 2:
Adrie Hello

Artist 2 makes a preliminary tonal sketch (below) that allows her to identify and accentuate any light and dark areas. Like Artist 1, she finds the photograph a little flat and prefers to liven it up using greater contrasts.

TONAL SKETCH
The tonal sketch uses different mixes of Payne's gray to establish the balance of light and dark, sunlight and shadow.

After mapping out the main elements, Artist 2 wets the paper and washes on a very diluted gold ocher with a No. 9 mop brush to give the picture a warm undertone. When this is dry, she spatters on masking fluid for a little added texture.

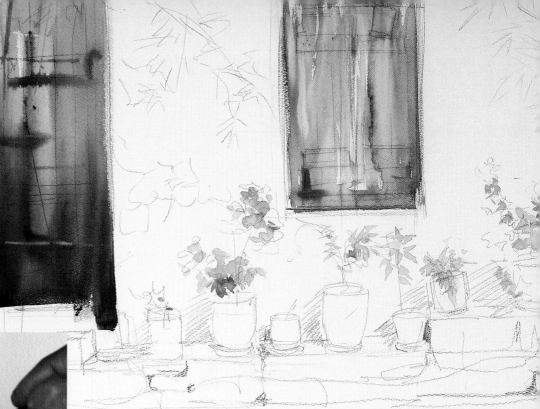

2 FIRST STAGES

After laying down the basic shapes in loose, sketchy lines, Artist 1 works in the texture of the wood on the door and shutters by painting vertical strokes of burnt sienna with touches of chrome yellow and vermilion. She then marks the position of some of the leaves of the potted plants with a mix of sap green and viridian.

Horizontal strokes across the bottom of the shutters capture the downward flow of paint.

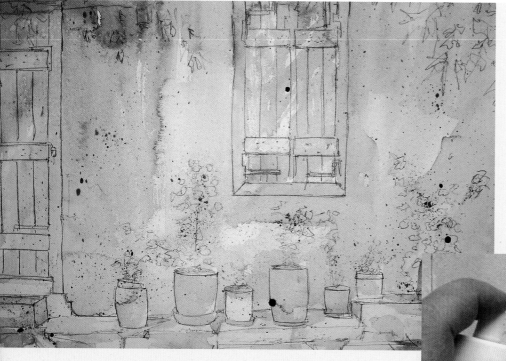

2 ADDING TEXTURE

When the masking fluid is dry, Artist 2 mixes brown madder and gold ochre, first brushing it loosely over the door, window, upper wall, and flowerpots. Before the paint dries, she sprays water onto it. The droplets form little "florets" of diluted pigment within the wash.

Texture is increased and edges softened by spraying water over the still-damp wash using an atomizer.

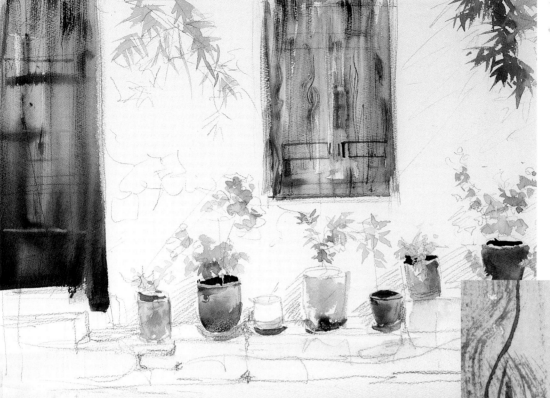

3 BUILDING UP TEXTURE
Working from top to bottom in vertical strokes, Artist 1 uses a few drybrush strokes of thicker paint to create the grainy patterns of the wood. She then adds fine lines in darker shades of burnt sienna using a rigger brush. The pots themselves are blocked in at this stage, along with the topmost leaves.

A close-up of a section of the shutters shows the dragged lines, drybrush strokes, and patterns made by the rigger brush.

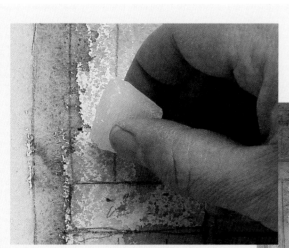

A white candle stub is rubbed over wood areas to increase texture and interest.

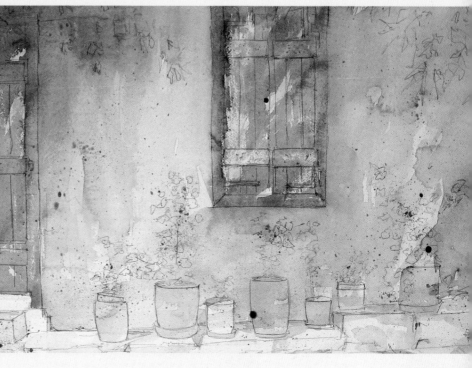

3 WOOD EFFECTS
To achieve the gritty effect of weather-worn wood, Artist 2 rubs candle wax over the door and window. She then brushes on a mixture of ultramarine and alizarin crimson over the wax, which resists the paint to produce a crackled, speckled effect.

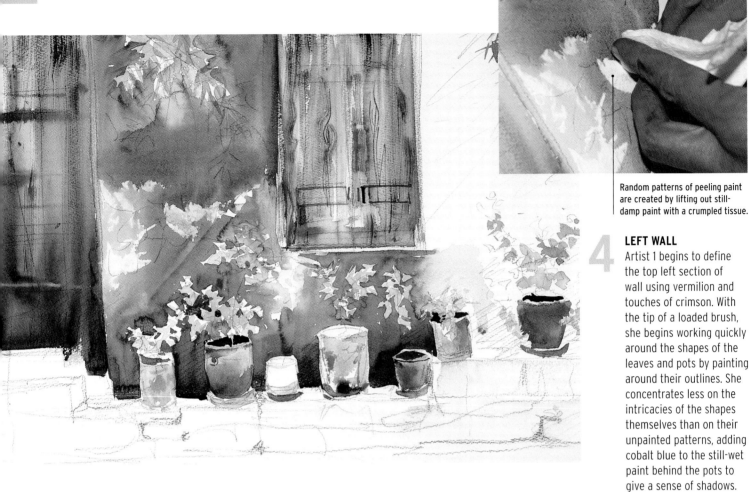

Random patterns of peeling paint are created by lifting out still-damp paint with a crumpled tissue.

4 LEFT WALL

Artist 1 begins to define the top left section of wall using vermilion and touches of crimson. With the tip of a loaded brush, she begins working quickly around the shapes of the leaves and pots by painting around their outlines. She concentrates less on the intricacies of the shapes themselves than on their unpainted patterns, adding cobalt blue to the still-wet paint behind the pots to give a sense of shadows.

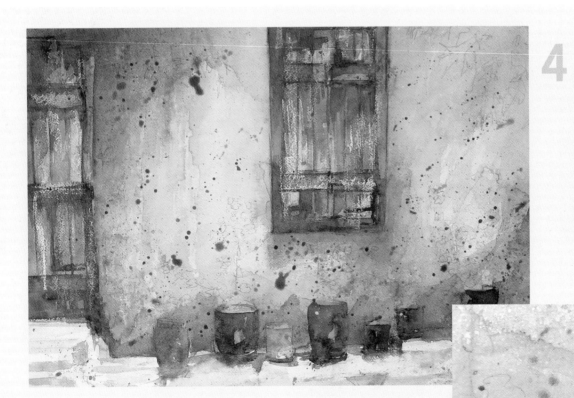

4 MORE TEXTURE

The wall becomes one of the fundamental features of the painting. Artist 2 rubs wax over it for texture before flooding the wall with a warm combination of gold ochre and Indian yellow. She creates shadows with a cooler mix of ultramarine and alizarin and paints the pots using cobalt blue for some and cadmium red for others.

The wall detail shows how texture is gradually built up using a combination of masking fluid, spattering, and spraying with water.

5 **RIGHT WALL**
Artist 1 uses the same technique on the right side of the wall, working from the top right and down to meet the softened edge of the last stage. Aware that this side of the wall lacks interest, she floods in a crimson and cobalt wash to create vibrant depth. Finally she sprinkles some water droplets into the still-damp paint for texture.

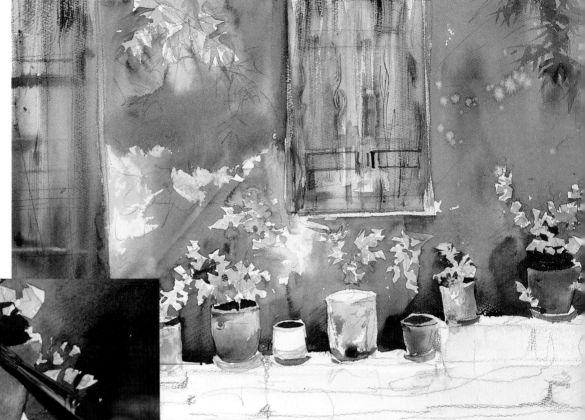

Painting intense darks into the shadows underneath the potted plants creates depth.

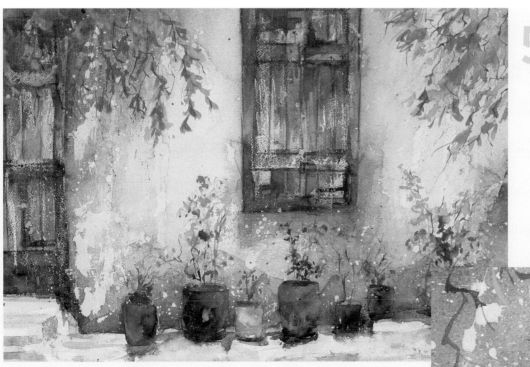

5 **GREENERY**
After removing the masking fluid from the wall's surface, Artist 2 paints the leaves with a mixture of Indian yellow, cadmium yellow pale, and raw umber. Ultramarine is applied to the darker leaves. Artist 2 strengthens the pots with cobalt blue and cadmium red, allowing the paint to blend into a soft gray wash for the stonework and street paving.

The leaves and branches are created using the tip of a rigger brush. The longer hairs hold more liquid and enable a long, continuous flow of paint.

FINISHING TOUCHES

Areas of shadow are added to the stones with various mixes of burnt sienna and cobalt blue. The rigger brush and a dark mix of crimson, cobalt blue, and burnt sienna is used to make fine lines on the woodwork and beneath some of the stones. The leaves are given extra definition with the same brush and color mix, and finally a more vibrant crimson is flooded in on the far right of the wall to contrast with the plant leaves.

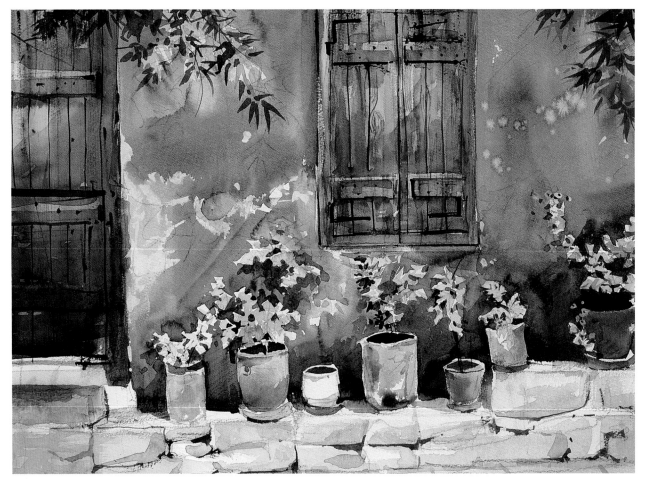

The loose textures of the wall contrast with the more linear treatment of the woodwork.

POTTED PLANTS (15 X 18 IN/37.5 X 47.5 CM, WATERCOLOR ON COLD-PRESSED WATERCOLOR PAPER)

"The photograph did not offer me the tonal patterns I normally go for, so I came up with a visual flow that is entirely my own. I am pleased with the wall's texture and the potted plants, rendered in detail yet still suggestive."

Milind Mulick

The green leaves on the red wall create an exciting dynamic of complementary colors, further accented by small areas of reserved white paper.

FINISHING TOUCHES

Finally, wanting to soften the painting, Artist 2 submerges the lower half of it in water and scrubs a few areas, especially those below the windowsill. When the paper is thoroughly dry, she concentrates on the balance of warm and cool colors to achieve the vibrancy of Mediterranean light, spattering on cadmium yellow pale, ultramarine, and burnt sienna.

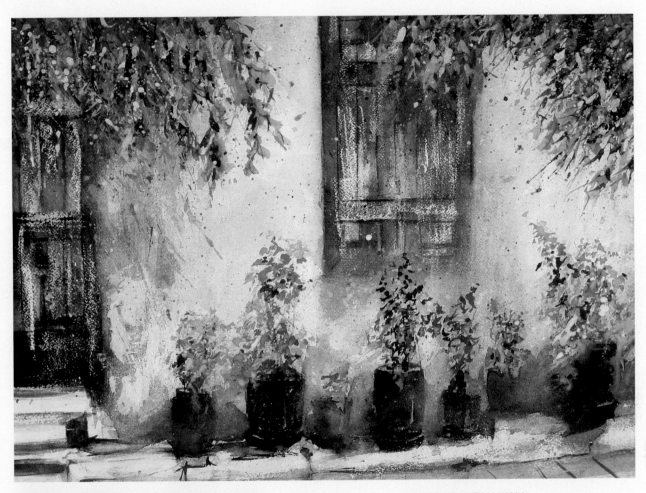

Textures here have been created by wax and masking fluid.

The leaves are super-imposed on the lighter wall, built up in layers of yellows and greens.

MEDITERRANEAN WALL (17 X 21 IN/44 X 54 CM, WATERCOLOR ON COLD-PRESSED WATERCOLOR PAPER)

"I was inspired by the charming wall, which is full of character. One of the issues I encountered with this watercolor was re-creating the quality of light that is typical of Europe's warm Mediterranean countries."
Adrie Hello

COMPARING THE WORKS
Color and texture play a defining role in the two finished pieces of art. With very little light or shade to work with, both artists have used a variety of techniques to create passages of interest and texture that lead the viewer's eye into and around the compositions.

Fields of lavender

One of the wonderful qualities of color is that you can use it in your paintings to suggest everything from mood to season and time of day. When painting this scene, artists Adrie Hello and Naomi Tydeman use different color temperatures (warm and cool) to create different moods and suggest varying times of day.

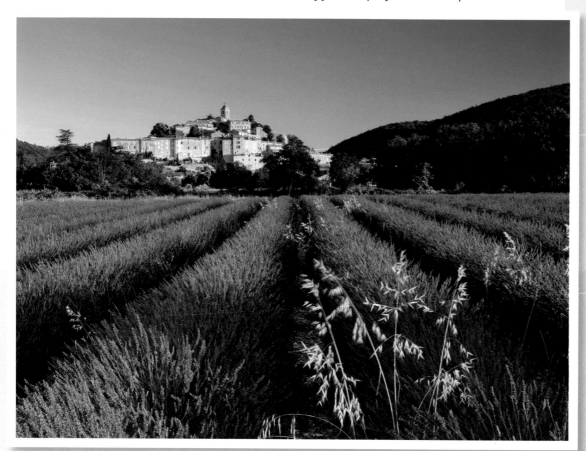

Palette
Payne's gray
Ultramarine
Cobalt blue
Cerulean
Alizarin crimson
Sap green
Brown madder
Burnt sienna
Raw sienna
Cadmium yellow
Gold ochre

Materials
Watercolor paper, cold-
 pressed
3B pencil
Masking fluid
Toothbrush
No. 4, No. 10, and No. 16
 round sable brushes
Large mop brush

Techniques
Masking out, page 21
Wet-on-dry, page 20
Wet-in-wet, page 20
Spattering, page 25

Palette
Alizarin crimson
Indigo
Winsor blue
Venetian red
Winsor lemon
Dioxazine violet

Materials
Watercolor board
2-inch (5-cm) flat brush
No. 5 and No. 10 round sable
 brushes
Stiff bristle brush

Techniques
Variegated wash, page 19
Using salt, page 26
Wet-into-wet, page 20
Spattering, page 25
Wet-on-dry, page 20

USING COLOR TEMPERATURE
Warm colors are associated with passion and energy, as well as afternoon and early evening; cool colors suggest peacefulness and serenity, as well as morning or night. For this painting, Artist 1 re-creates the late-afternoon atmosphere of the reference photo, using warm oranges and redder purples to depict the rows of lavender and the distant village. Artist 2, however, tones down the scene and uses cool grays and bluer purples, suggesting a tranquil morning.

1

ARTIST 1:
Adrie Hello

Artist 1's preliminary tonal sketch using payne's gray allows her to identify the light and dark areas of the composition and explore the texture of the lavender in the foreground. She decides she will use spattering methods in the painting, so she tries them out in the sketch.

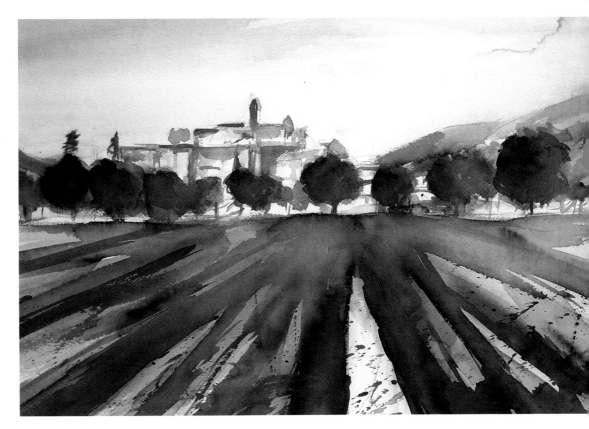

1

ARTIST 2:
Naomi Tydeman

Artist 2 decides to accentuate a few small details in her composition. The trees within the village are made taller to punctuate the sky, and the glimpse of the field on the far right of the composition is lengthened.

The subject's details are subtly altered for a more effective composition.

Artist 2 lays down the initial wash for the sky, using Winsor blue with a touch of Venetian red to tone it down. A little alizarin crimson is added to provide a ground for the lavender. Sensing that the sky looks too bland, she livens it up by spattering diluted paint from a 2-inch (5-cm) flat brush.

2 SKETCH

Artist 1's simple line drawing on watercolor paper using a 3B pencil pinpoints the location of the village houses, trees, and rows of lavender. She reserves the sunlit walls of the village with masking fluid before spattering it over the lavender in the foreground and allowing it to dry.

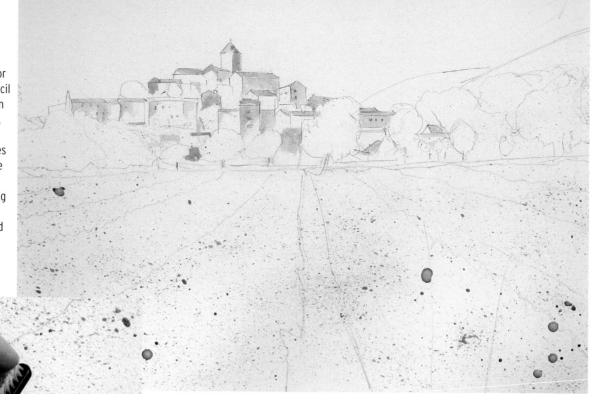

An old toothbrush is loaded with masking fluid to spatter texture over the flowers that appear in the foreground.

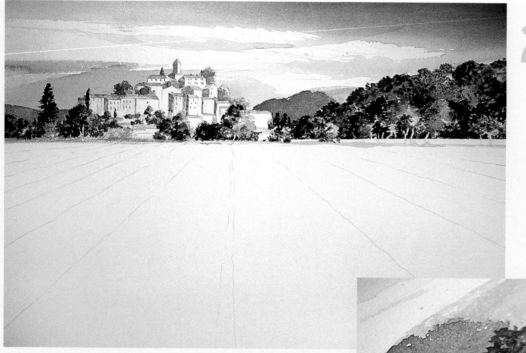

2 BACKGROUND

The terracotta rooftops are painted with Venetian red, and shadows are defined with a touch of the sky wash. For the trees, Artist 2 uses Winsor lemon and Winsor blue in varying amounts, and adds some of the sky colors to the shadows. Some salt is sprinkled on as the paint begins to dry to add texture to the foliage.

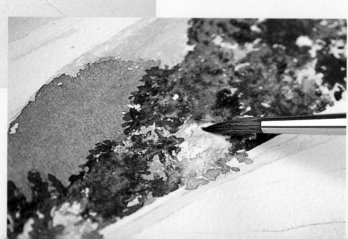

The No. 5 round sable brush is loaded with a dark mix of Winsor lemon and Winsor blue to enhance the tree shadows.

3 INITIAL WASH

Artist 1 tilts the board at a 40° angle and washes in cobalt blue and alizarin for the sky. She also adds a touch of cerulean blue to the left side of the painting. She brushes the same purple wash into the lavender rows and paints some raw sienna between them and along the far edge of the field.

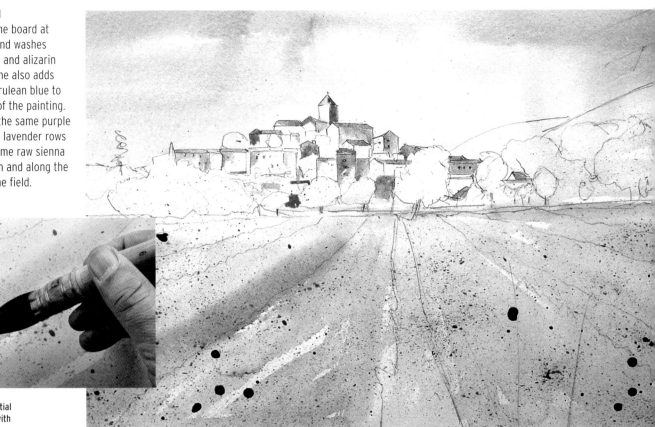

A loose and free initial wash is laid down with a large mop brush.

3 LAVENDER

Artist 2 mixes a large quantity of alizarin crimson, dioxazine violet, and indigo, which she then loosely brushes over the lavender with the 2-inch (5-cm) flat brush. Working wet-in-wet, she spatters on darker paint, splashes some water droplets, sprinkles salt crystals, and works shadows into the lines of lavender.

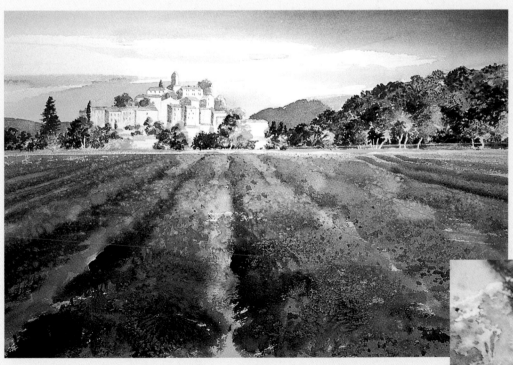

Stronger pigment is added to the lavender shadows.

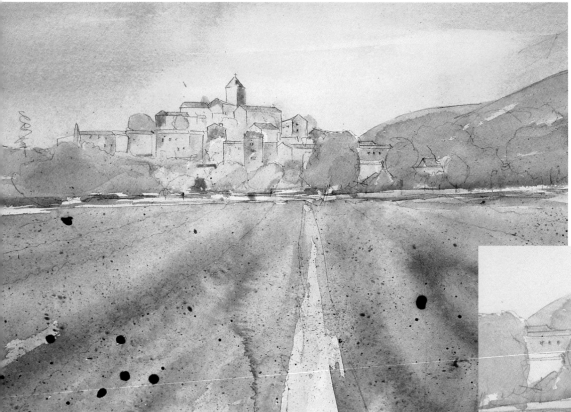

4 SECOND LAYERS

Artist 1 paints the hills using cobalt blue with a touch of cadmium yellow. Sap green is added to the mix for the rows of trees along the far edge of the field. A stronger wash of ultramarine and alizarin is loosely washed over the lavender, following the direction of the rows.

The trees are painted wet-in-wet into the still-damp hillside using the No. 10 round sable brush.

The point of the No. 5 round sable brush is used to increase texture in the lavender.

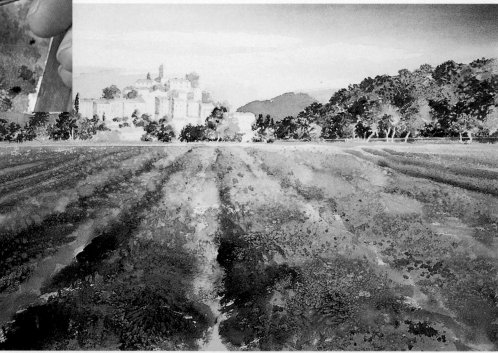

4 LAVENDER DETAILS

Artist 2 defines the texture and structure of the lavender as it comes toward the viewer, scumbling into the middle ground and defining stalks in the foreground.

5 STRENGTHENING TONES

After painting gold ochre over the houses, Artist 1 removes the masking fluid from the highlighted areas and works into the trees with a strong variegated wash of sap green, ultramarine, and burnt sienna. Shadow lines between the rows and smudges of green from the trees add color and depth to the lavender.

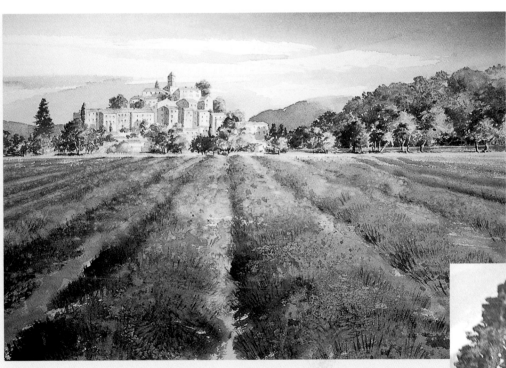

Fingertips are used to remove the masking fluid and reveal the sunlit walls of the village.

5 BUILDINGS

Artist 2 uses the sky wash and the No. 5 brush to add some definition to the windows and shadows of the houses.

The narrow band of light behind the trees is accentuated by adding strong darks above it.

FINISHING TOUCHES

More colors, including brown madder, gold ochre, and burnt sienna, are added to the houses to bring out the warmth of the walls and roofs. Artist 1 then works into the lavender, spattering more masking fluid before another layer of ultramarine and alizarin crimson is added, with some stronger version of the same colors dropped in wet-in-wet. She finally decides to spatter some rich yellows over the complementary purples to give additional vibrancy.

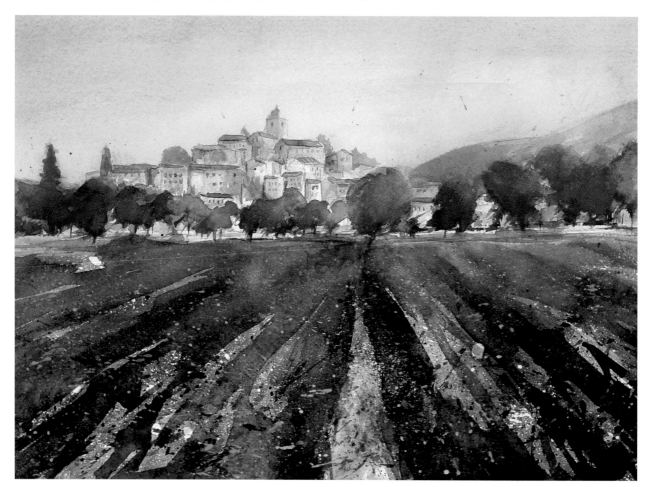

Loose and gestural areas of soft-edged washes alongside sharper edges create interest and liveliness.

Layers of intense and complementary colors create the vibrancy of sunlight on fields of flowers.

LAVENDER
(44 X 54 IN/17 X 21 CM WATERCOLOR ON COLD-PRESSED WATERCOLOR PAPER)

"For me, the main challenge in this work was to get the texture of the lavender into a loose painting, full of the summer atmosphere of the south of Europe."

Adrie Hello

FINISHING TOUCHES
In the final stages, Artist 2 softens the lime green band across the middle, and then pushes the distant hills farther back in space by lifting out a little color.

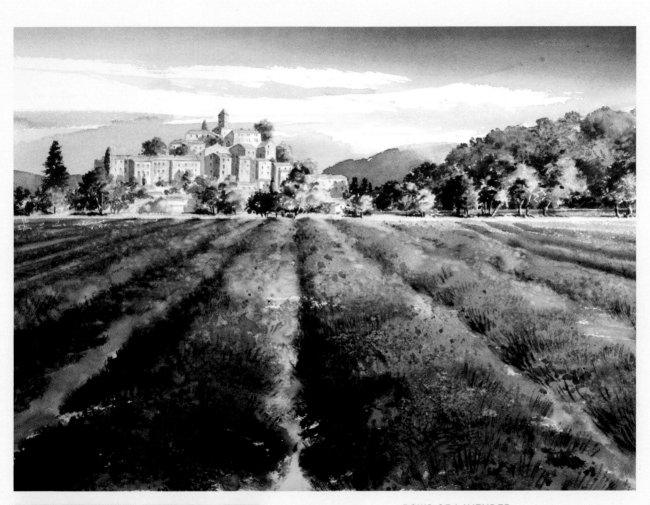

Passages of light and dark create the rows of lavender that lead the eye to the trees beyond.

Texture created from salt, sprayed water, and spatterings of darker paint blend to suggest thousands of lavender florets.

ROWS OF LAVENDER
(15 X 22 IN/38 X 56 CM, WATERCOLOR ON WATERCOLOR BOARD)

"This was quite a difficult painting, in terms of laying down the lavender fields and having to cope with perspective and shadows and light and receding detail all at once. Touching in little details afterward was like lying on a beach after nearly drowning."
Naomi Tydeman

COMPARING THE WORKS
With two different color schemes, both works offer completely different interpretations of the same subject. The warm colors of Artist 1's painting evoke energy and excitement, whereas the cool colors of Artist 2's painting create a moody sense of calm and quiet.

Man and boat

The patterns created by light and shadow can be so compelling that they become the focus of the painting in lieu of the physical elements in the scene. In this lesson, artists David Poxon and Doug Lew take different approaches in depicting the interplay of light and shadow across the front of the boat.

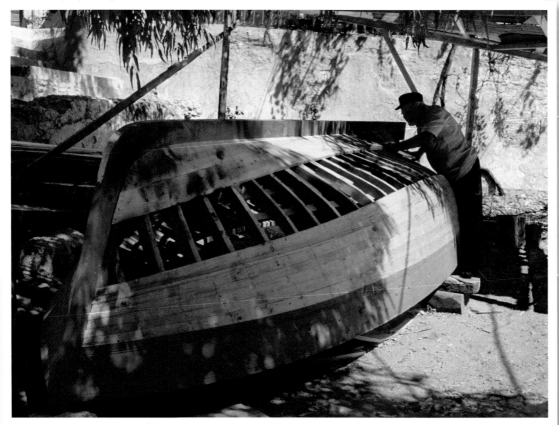

ALTERING TONES

The tonal value of the boat in the reference photo is very dark in areas of shadow, making it difficult to "read" the shapes and textures. To remedy this, both artists lighten the tones of the entire scene. Artist 1 stays fairly true to the reference, but he lightens the value of the shadow across the boat and brightens the colors on the hull. Artist 2 also lightens the shadow on the boat but adds even more contrast by adding a strip of almost-white sunlight across the scene.

■ **Palette**
Yellow ochre
Raw sienna
Burnt sienna
Phthalo blue
Alizarin crimson
Manganese blue

■ **Materials**
Cartridge paper
Watercolor paper
2B pencil
Masking fluid
Tissue
Various brushes in sable/
 nylon mix
Stiff bristle brush

■ **Techniques**
Masking out, page 21
Wet-in-wet, page 20
Wet-on-dry, page 20
Spattering, page 25
Lifting out (dry), page 22
Glazing, page 21

■ **Palette**
Raw sienna
Burnt sienna
Cadmium red medium
Sepia
Indigo
Cobalt blue

■ **Materials**
4B pencil
Watercolor paper, rough
1-inch (2.5-cm) oval brush
$^{3}/_{8}$-inch (1-cm) flat brush
No. 10 round brush

■ **Techniques**
Wet-on-dry, page 20
Wet-in-wet, page 20
Drybrush, page 23
Lifting out (wet), page 22

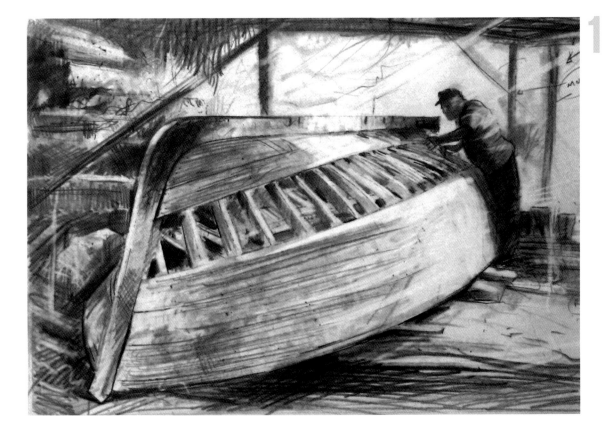

ARTIST 1:
David Poxon

Artist 1 makes several sketches both to practice drawing the boat and to work out any compositional concerns. He moves the distracting post up and away from the figure, echoing the man's pose. Then he transfers the essential lines to the watercolor paper.

ARTIST 2:
Doug Lew

Artist 2 decides to enlarge the foreground and push the boat back into the picture, creating a greater sense of depth and space. He works this out on a sketch and then maps out the values.

The simple tonal sketch divides the scene into light, middle, and dark areas.

After sketching the major outlines on the watercolor paper, Artist 2 floods a light raw sienna wash over the boat. He then paints the background with a cool, recessive blue-gray mixed from indigo and cobalt blue.

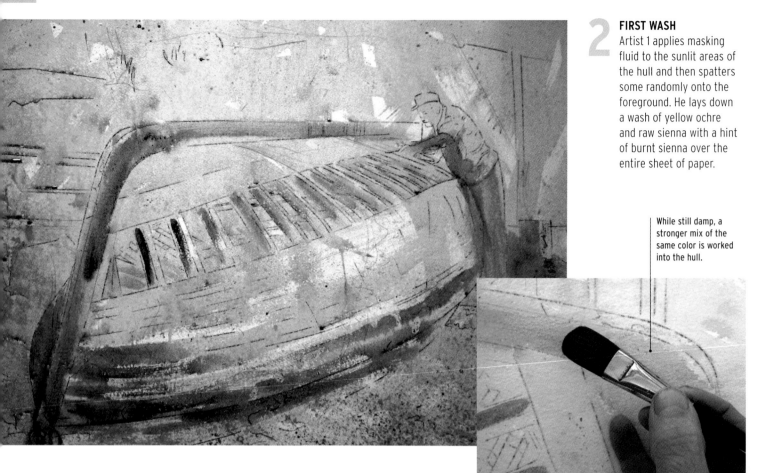

2 FIRST WASH

Artist 1 applies masking fluid to the sunlit areas of the hull and then spatters some randomly onto the foreground. He lays down a wash of yellow ochre and raw sienna with a hint of burnt sienna over the entire sheet of paper.

While still damp, a stronger mix of the same color is worked into the hull.

2 BOAT SHADOWS

Artist 2 blocks in the orange sections of the boat by mixing together cadmium red medium and raw sienna. When this is dry, he adds the earlier blue-gray mix for the shadows, warmed with a touch of the orange mix.

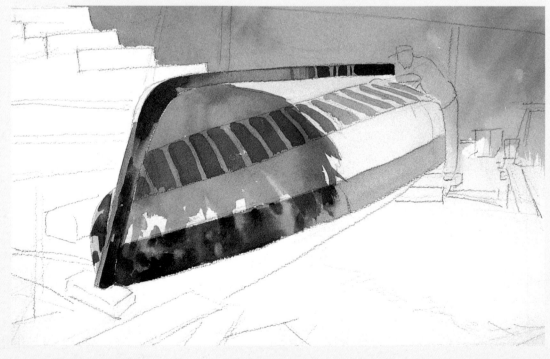

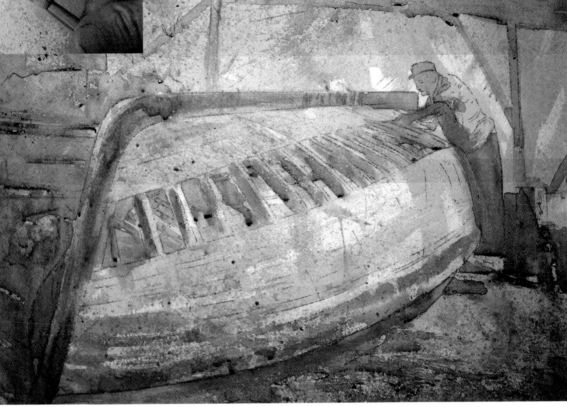

Some of the colors previously used to add texture to the hull and the foreground are spattered on using a stiff bristle brush.

3 SECOND WASHES

Artist 1 lays down the shadow areas using a gray mix of phthalo blue and burnt sienna. He intensifies the darker sections by glazing wet-on-dry, allowing him to build up the correct values for a greater sense of depth.

3 SHADOW AREA

Artist 2 lays down the shadows on the left using mixes of indigo, cobalt blue, and sepia. Once the colors have blended together, his drybrush strokes add texture to the wooden planks.

The foreground edges are kept soft to avoid drawing too much attention.

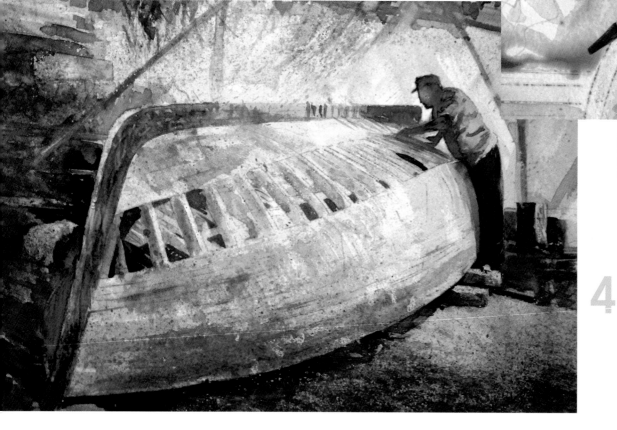

A darker mix of phthalo blue and burnt sienna is worked into the shadow areas wet-in-wet, using a small brush.

4 BUILDING UP DARKS

When the paint has dried, Artist 1 removes the masking fluid by rubbing with a finger. Then he uses various combinations of the same four colors to build up the darks and define the boat and figure.

4 STRENGTHENING SHADOWS

Artist 2 now adds stronger mixes of the same color under and around the boat. He gives the wooden planks stronger definition and creates interest in the shadows on the steps with a damp brush and clean water.

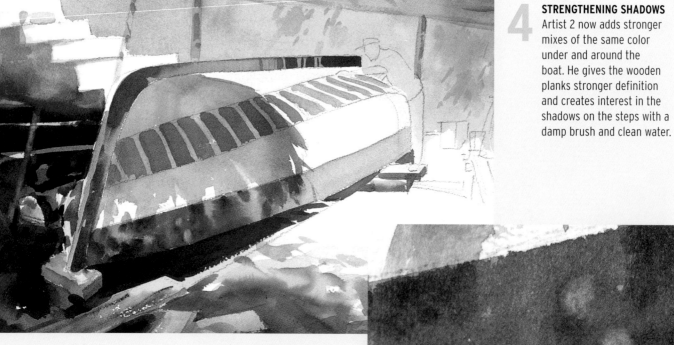

Clean water and a damp brush are used to lift out areas of the hull and indicate a dappled light effect.

5 DEFINING CONTOURS

The painting begins to come together as Artist 1 deepens the shadows behind the boat. Using a mix of manganese blue and yellow ochre, he proceeds to add shadows to the hull to help define its form.

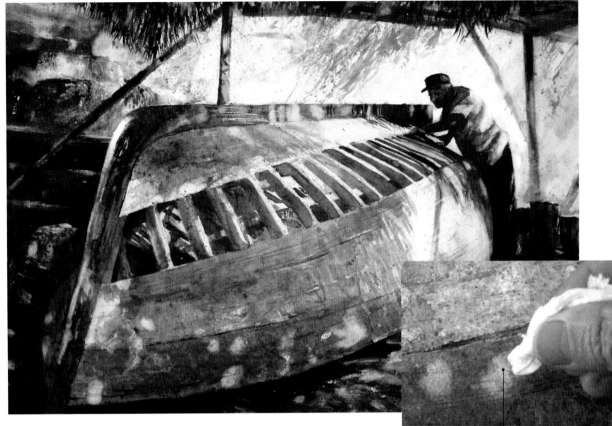

A damp bristle brush is used to scrub off small areas of paint from the hull, and then a tissue is used to lift out some pigment to produce the effect of dappled light.

5 THE HUMAN FIGURE

Artist 2 works in the figure using strong and weak variations of the shadow color he used in step 3—mixes of indigo, cobalt blue, and sepia. He then works shadows into the ribs of the boat using a stronger sepia mix of these colors. He also adds a couple of cans behind and to the right of the figure, echoing the two main colors.

Artist 2 eliminates the light showing through the ribs, as they add little to the composition.

FINISHING TOUCHES

Using burnt sienna, alizarin crimson, and yellow ochre, Artist 1 intensifies the coloring of the boat. Edges and details are refined with progressively smaller brushes. Artist 1 then decides that the keel of the boat is too close to the figure's head. With clean water and the bristle brush, he shortens the keel. Some final touches to the dappled light and shadows bring it to completion.

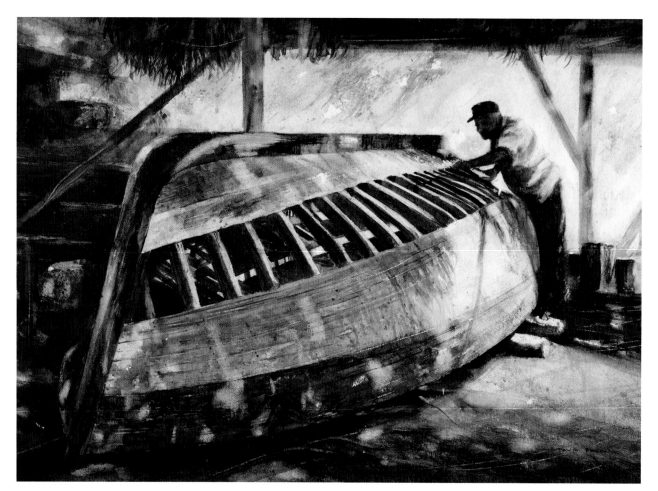

The patterns of light catching the ribs on the other side of the hull emphasize the three-dimensionality.

The white wall behind the boat reflects light and intensifies the feeling of a hot day.

DAYS LIKE THESE
(20 X 27 IN/51 X 69 CM, WATERCOLOR ON WATERCOLOR PAPER)

"Dappled sunlight dances across this scene as a craftsman renovates an old boat. Unifying this figure with his environment through the use of a limited palette, lost and found edges, and other techniques was key to a successful painting. Becoming absorbed in the creative process is one of life's great pleasures."

David Poxon

FINISHING TOUCHES

Artist 2 paints the wall shadows and some of the detail of the roof using a stronger variation of the shadow color. A little of the yellow mix for the boat is added to the planks in the foreground, and touches of the shadow color are worked in while this is still wet. Finally, he adds the loop of rope hanging from the roof.

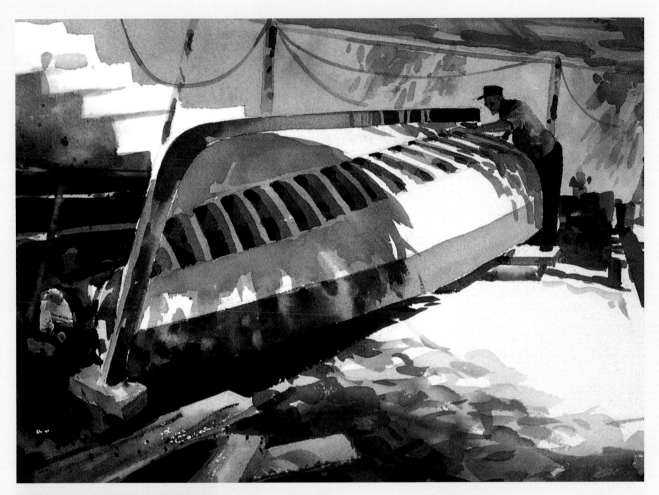

Simplifying the patterns within the hull leads the eye to the shapes and shadows behind the boat.

The wet wash over the wall pushes it back and accentuates the strong band of light.

THE BOAT YARD (12½ X 17¾ IN/32 X 45 CM, WATERCOLOR ON ROUGH WATERCOLOR PAPER)

"The first thing that hit me was the strong source of sunlight falling on the boat yard. I wanted to maintain that strength and perhaps even to heighten it. I did several sketches to help clarify distance and depth and to add more foreground."

Doug Lew

COMPARING THE WORKS

Both artists focus on the interplay of light and shadow in their paintings, though their color choices produce very different results. Artist 1's painting makes use of warm oranges and yellows, whereas Artist 2's scene is imbued with blue for a cool, almost underwater feeling. Artist 2 also pushes the boat back into the scene, increasing the foreground and creating a greater sense of depth.

Index

Credits

All photographs and illustrations are the copyright of Quarto Inc.

While every effort has been made to credit contributors, Quarto would like to apologize should there have been any omissions or errors, and would be pleased to make the appropriate correction for future editions of the book.

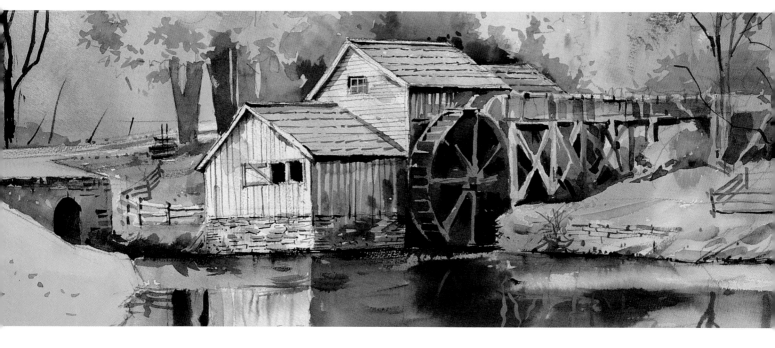